Louis M. Eilshemius

[1864–1941]

AN INDEPENDENT SPIRIT

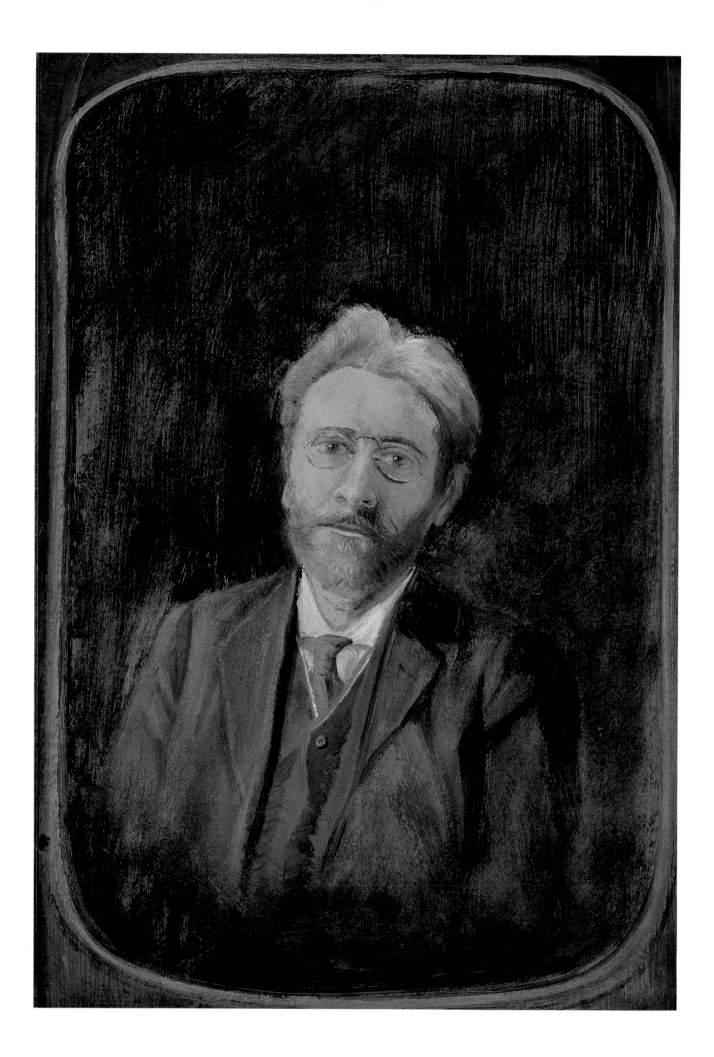

Louis M. Eilshemius

[1864–1941]

AN INDEPENDENT SPIRIT

Steven Harvey

✳ ✳ ✳ ✳ ✳ ✳

With an essay by Paul J. Karlstrom

National Academy of Design

NEW YORK

Frontispiece: *Self-Portrait*, 1915, Collection Gertrude Stein
(cat. no. 34)

This catalogue accompanies an exhibition curated by Steven Harvey
September 19–December 30, 2001
National Academy of Design
1083 Fifth Avenue
New York, New York 10128

This catalogue was made possible by funding from
Lawrence B. Salander and the Lucelia Fund for Publication
of the National Academy of Design.

Major support for the exhibition was provided by the Roy R. and
Marie S. Neuberger Foundation. Additional support was provided by the
J. Aron Charitable Foundation and the National Academy of Design
Exhibition Fund. Further support was provided by Paul Resika, NA.

"An Informal Talk by Mr. Louis Eilshemius," October 15, 1920,
from the Katherine Dreier Papers/Société Anonyme Archive has been published
by permission of Beinecke Rare Book and Manuscript Library,
Yale University, New Haven, Connecticut.

Printing: The Studley Press, Dalton, MA
Design: Lawrence Sunden, Inc., Harrington Park, NJ
PRINTED IN THE UNITED STATE OF AMERICA

Library of Congress Cataloging-in-Publication Data

Harvey, Steven O'L.
 Louis M. Eilshemius : 1864–1941 : an independent spirit / Steven Harvey with an essay
by Paul J. Karlstrom
 p. cm.
 "This catalogue accompanies an exhibition curated by Steven Harvey,
National Academy of Design, New York, September 19–December 30, 2001."
 Includes bibliographical references.
 ISBN 1-887149-09-0
 1. Eilshemius, Louis M. (Louis Michel), 1864–1941 -- Exhibitions. I. Eilshemius, Louis
M. (Louis Michel), 1864–1941. II. Karlstrom, Paul J. III. National Academy of Design
(U.S.) IV. Title.

ND237.E45 A4 2001
759.13--dc21

 2001044394

TABLE OF CONTENTS

DIRECTOR'S FOREWORD AND ACKNOWLEDGEMENTS

Annette Blaugrund

For years the artist Louis Eilshemius sought popular and peer recognition, but his quest remained unrealized. Only after he stopped painting did he achieve a modicum of appreciation and commercial success.

To understand the aesthetic climate in which Eilshemius worked, one must recall that up until the turn of the last century, the National Academy of Design was one of the most prestigious and important places in which to exhibit contemporary art. Membership in the Academy gave status to artists who placed the coveted initials N.A.—National Academician—after their signatures. Eilshemius's paintings had been accepted into Academy exhibitions only twice, in 1887 and 1888, but never again, to his consternation and displeasure.

While Eilshemius sought to become an Academician, other artists rebelled against the National Academy of Design beginning as early as 1877, with the formation of the Society of American Artists (SAA). This group of artists, including George Inness, John La Farge, and William Merritt Chase, retaliated against the Academy's unresponsiveness to progressive art by holding their own exhibitions. By 1906, the SAA itself became moribund in the eyes of younger, avant-garde artists and merged with the Academy.

During the first two decades of the twentieth century, independent art exhibitions became the standard method used by American artists to challenge academic traditions and authority. In 1908, eight painters—Robert Henri, George Luks, John Sloan, William Glackens, Everett Shinn, Maurice Prendergast, Ernest Lawson, and Arthur B. Davies—exhibited together at the Macbeth Gallery in New York City. It was their rebuttal to the National Academy of Design which had rejected from the Annual Exhibition the work of three artists in their group. Like the eight artists, Eilshemius often painted city scenes, yet he was not part of this group which affirmed not only the principle of nonjuried exhibitions, changed the perception of the artist's role in society, altered the way art was marketed and promoted, and paved the way for modernism in the United States. The show at the Macbeth Gallery anticipated the Independent Artist Exhibition organized by Robert Henri in 1910 in which 103 artists participated, but once again without Eilshemius. Such events continued through the teens, the most important being the Armory show in 1913.

Arthur B. Davies, a painter of idyllic nudes who had a taste for radical European art, was one of the organizers of the Armory show. This International Exhibition of Modern Art encapsulated the development of nineteenth- and twentieth-century movements from impressionism, fauvism, and cubism, to various expressionist styles, and introduced unsophisticated American audiences to new modernist trends. Eilshemius, along with many Academicians, was not included in this groundbreaking exhibition even though he was already experimenting with anti- academic ideas.

It was not until the 1917 exhibition of the Society of Independent Artists that Eilshemius met with success, as Steven Harvey and Paul Karlstrom recount in their essays. Eilshemius's two paintings were noticed by Marcel Duchamp who selected Eilshemius's *Rose-Marie Calling (Supplication)* from among the 2000 works in the show. From that time forward he arranged for Eilshemius to have solo exhibitions, which eventually led to his representation by a dealer who promoted his work.

Collectors such as Roy R. Neuberger, Joseph H. Hirshhorn, Chester Dale, and Duncan Phillips, among others, bought and championed Eilshemius's work in the 1930s and 40s. In fact, almost every major museum has at least one Eilshemius in its collection. Although his work is infrequently exhibited, interest in this neglected artist recurs periodically. The Museum of Modern Art recently exhibited two of his paintings (2000). Among artists, then and now, his work remains appealing for its acquired naïve style, its tonal palette, and to some extent because he symbolizes the essence of an outsider and thereby endures as an American original.

Organized in response to the widespread appreciation for the work of Louis Eilshemius among current Academicians, this exhibition is both fitting and meaningful, for it commemorates the sixtieth anniversary of the artist's death in December 1941. Eilshemius desperately wanted to be associated with the Academy and now, at long last, he is. The members of the National Academy of Design voted to make him an honorary member at their annual meeting in 2001.

Projects such as this one could not take place without financial assistance. We are most grateful to the Roy R. and Marie S. Neuberger Foundation for its generous support of this exhibition and to Roy Neuberger for the many loans of

paintings from his personal collection. We greatly appreciate the funding of the catalogue by Lawrence B. Salander, who has been supportive from the beginning, and the Academy's Lucelia Fund for Publication.

Steven Harvey served as the guest curator of the exhibition, which this catalogue accompanies. Mr. Harvey is responsible for some new discoveries which are found in his informative essay. Dr. Paul Karlstrom has contributed a reappraisal of Eilshemius almost thirty years after his groundbreaking dissertation and book on the artist. This exhibition is the brainchild of Paul Resika, former chairman of the Academy's exhibition committee, who knew of Mr. Harvey's work on Eilshemius. The Academy's Curator of Contemporary Art, Isabelle Dervaux, supervised the project in-house, for which we are very appreciative.

Steven Harvey wishes to express his gratitude to Roy Neuberger and Lawrence Salander, whose enthusiasm for Eilshemius encouraged this exhibition; to the individual collectors, galleries, and museums who were kind enough to lend works; to the Exhibition Committee of the National Academy who proposed the Eilshemius exhibition; to Academicians Raoul Middleman, Paul Resika and Gregory Amenoff; to Dr. Annette Blaugrund and the staff of the Academy including Dr. David Dearinger, Cecilia Bonn, Paula Pineda, Wendy Rogers and especially Dr. Isabelle Dervaux; to Dr. Paul J. Karlstrom, to Patricia Magnani, Gloria Silverman and Dr. Lucinda H. Gedeon; to Catherine A. Bernstein, Leigh Morse, Fred Bancroft, Paula Hornbostel, Alice Engel, Paul Waldman, Larry Sunden and Bil Thibodeau; to Gertrude Stein, Robert K. Fitzgerel, Geoff Robinson, William S. Lieberman, John Driscoll, Francis Naumann, Michael Werner; and his special thanks to Jennifer Sachs Samet.

The Academy is grateful to all of the lenders listed herein, for without their participation we could not have shown Eilshemius at his best. Lastly, I want to thank the entire staff of the National Academy of Design for their help and expertise.

LENDERS TO THE EXHIBITION

Addison Gallery of American Art, Phillips Academy, Andover, Massachusetts

Berry-Hill Galleries, New York

Robert K. Fitzgerel Collection

Herbert Lust Gallery, New York

Hirshhorn Museum and Sculpture Garden, Smithsonian Institution, Washington, D.C.

Shirley and Jack Mandel

The Metropolitan Museum of Art

The Museum of Modern Art, New York

Roy R. Neuberger

Neuberger Museum of Art, Purchase College, State University of New York

New Jersey State Museum

The Phillips Collection, Washington, D.C.

Private Collection

Samuel L. Rosenfeld Collection, New York

Salander-O'Reilly Galleries, New York

Smithsonian American Art Museum

Harry and Cookie Spiro

Collection Gertrude Stein

Whitney Museum of American Art, New York

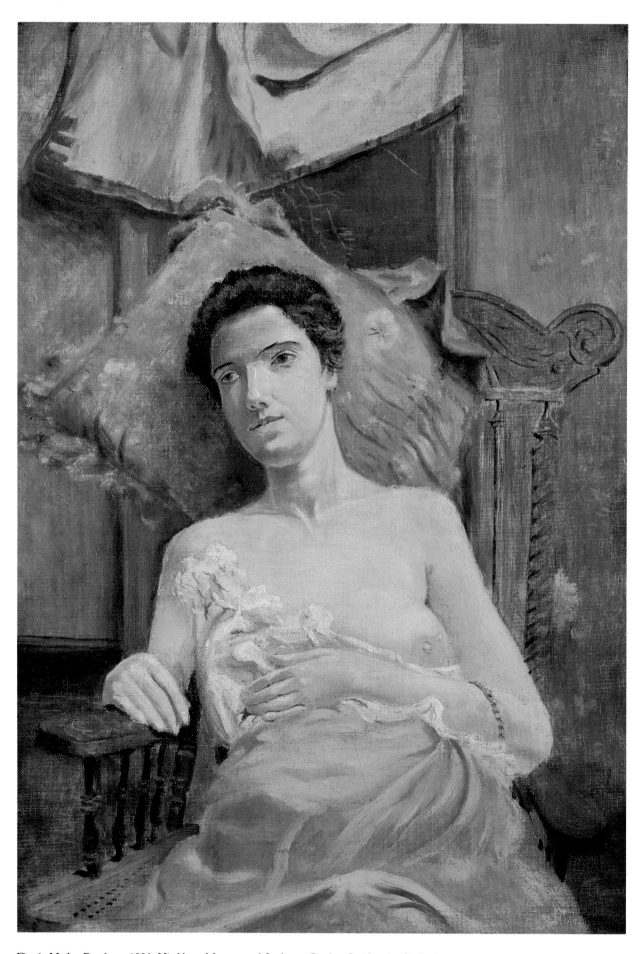

Fig. 1 *Mother Bereft*, ca. 1890, Hirshhorn Museum and Sculpture Garden, Smithsonian Institution.
Gift of the Joseph H. Hirshhorn Foundation, 1966 (cat. no. 2)

Against the Grain

THE PAINTINGS OF LOUIS MICHEL EILSHEMIUS

❋ ❋ ❋ ❋ ❋

Here he comes— Eilshemius. He is dressed in wide sand colored trousers and a faded green coat; his face is that of a ceaseless smoker, and in his orange hair there is a frost of gray. It is visible that his beard received no attention from a barber. His head is tossed back as if the Mahatma is listening to the reciting of exquisite modern poetry. Eilshemius speaks loudly and independently.

— David Burliuk[1]

The real object of art is to represent on canvas the soul of things, of persons and of landscape. The other thing is just painting," stated Louis M. Eilshemius (1864–1941). This statement, delivered in a lecture he gave on the occasion of his first exhibition at the Société Anonyme in 1920, defined his mission as a painter, which was to infuse the works he painted from nature, as well as those painted from his imagination, with a depth of feeling he termed "soul quality."

Eilshemius himself was an extraordinary "soul." If he is known at all now, it is mostly as a legendary bohemian figure of early twentieth-century New York. He referred to himself as the Mahatma, the Supreme Spirit of the Spheres. He would approach people in galleries, and say, "Why are you wasting your time on these worthless pictures. If you want to see real art why don't you come to my studio?"[2] Eilshemius was multifaceted, describing himself as a painter-poet-musician. He wrote and published his poetry and prose, composed music and painted. In his later years he promoted quasi-scientific discoveries in pamphlets, including his 'patented' self-painted frames. In one he proclaimed himself an "Educator, Ex-actor, Amateur All Round Doctor, Mesmerist-Prophet and Mystic, Reader of Hands and Faces, Linguist of 5 Languages," a "Spirit-Painter Supreme," as well as the "Most wonderful and diverse painter of nude groups in the world," whose " middle name is variety." While all of this adds up to a picture of a vivid and grandiloquent eccentric, it also has served to obscure his painting.

Eilshemius was an extraordinary and innovative painter who always possessed his own voice. The combination of his eccentric personality—he has been described as suffering from a serious mental illness—and the often-shocking subject matter of his paintings have led art historians and critics to categorize him as a primitive. He was actually, however, an academically trained and sophisticated painter, who is part of a lineage of modern art that begins with Corot and continues from Derain and Balthus to many contemporary painters. The lecture that Eilshemius delivered at the Société Anonyme—published herein for the first time—sheds new light on his sources, his beliefs about painting, and his development as an artist.[3]

Through his inventiveness and relentless productivity, Eilshemius found his subjects: the landscape, the city, vision and myth, and, above all, hundreds of paintings of the nude, mostly pictured outdoors. These coarsely featured voluptuous women, floating over the waves or flying through space, displayed a gaping, awkward sexuality that was too intense to be accepted in the United States at the time.

As a young painter his primary model was Jean-Baptiste-Camille Corot, the most poetic of French landscape painters. Corot balanced his interest in painting from nature with an abstract conception of painting as studio practice. As a student, Eilshemius rebelled against the repetitive regimen of copying from the casts and the model in art school, preferring the freedom of painting outdoors. The teacher who helped him the most was the American Barbizon painter Robert C. Minor, who guided him to the French landscape tradition. In the work of the French Barbizon painters (along with Corot and Courbet), Eilshemius found the example of painting in direct response to nature, combined with a more poetic studio practice.

Eilshemius came from a wealthy, cultivated, first generation family of French-Swiss and Dutch-German lineage; he was educated in Germany, and studied painting in New York, Paris, and Antwerp. He brought a European sensuality to his work that was missing from American art of the period. His formal and imaginative originality relates his work to other progressive American artists of the period—notably George Inness, Ralph Albert Blakelock, and Albert Pinkham Ryder. American painting in the mid-nineteenth century was primarily about empirical observation, anec-

dote, sentiment, and effect. Painters recorded the new landscape with verisimilitude. Eilshemius's understated and plain-spoken approach to the landscape went against the grain of the American work ethic in art, which demanded finish, exactitude, and virtuosity.

Though born into comfortable circumstances, Eilshemius's personal life was difficult—filled with loss and artistic rejection. He lost three of his five siblings early in life. For the greater part of his career, he was unable to interest others in his work. This combination of loss and rejection may account for his extreme and voluble personality. His response to rejection was a defensive antagonism that led him to attack most other forms of both traditional and modernist art.

The National Academy of Design accepted Eilshemius's paintings only twice for annual juried exhibitions, in 1887 and 1888. After that, his work was consistently rejected. Still he continued to submit his work, always hoping for the Academy's approval. Academic approbation was so important to him that later in life, unable to use the N.A. designation of National Academician, he invented an honorific, M.A. (Master of Art), which he claimed to have received from Cornell University (which he did attend for a year). After 1932, when he had been injured in an automobile accident, and was largely confined to his family brownstone at 118 East Fifty-seventh Street, he would call out to visitors coming up the stairs, "Bring any members of the Academy with you?" Because of the artist's lifelong love-hate relationship with the Academy, there is a distinct sense of poetic justice, as well as irony, in presenting Eilshemius at the National Academy of Design in 2001.

THE METAPHYSICAL LANDSCAPE

"Nothing is bathed twice in the same river," which proves . . . that a river is at once abstract concept and living thing. . . If one wants to paint a river one must be capable of giving it these two properties at the same time.

—Andre Derain[4]

In the fall of 1886 Eilshemius traveled to Paris with his friend, the painter and writer Robert Chambers. They took a studio on rue de Vaugirard across from the Luxembourg Gardens and attended the Académie Julian. Julian's, where Adolphe William Bouguereau was then teaching, was attended by many American artists who found it a good place in which to draw from the model and receive instruction and

weekly criticism.[5] Eilshemius's rebellious nature was quickly apparent. On November 15, 1887, he wrote in his journal:

A close unwholesome air nigh most caused me to faint. And there they (the students) draw—during the day—ever from one single model. Their mind [sic] is filled with monotonous study, monotonous observation and ever recurring shapes to be continually copied. I grew disgusted with the idea and was glad to avow to myself that the real artist is spontaneous, is creative.[6]

In Paris, in a pattern that continued throughout his life, he spent a great deal of the time alone, often reading in the library of the Sorbonne. One such evening he had a revelation. In the introduction to his sonnet sequence *Mystery and Truth*, he describes how, in the process of reading an occult text, he came to the realization that "if the Will was active, everything could be accomplished."[7] He immediately set himself the test of writing fifty sonnets over the next three days, for four hours each day. This was the beginning of Eilshemius's mystical belief in his ability to perform Herculean feats of creation. He describes writing a comedy of 102 pages in twenty-six hours, or making paintings in fifteen minutes[8]. From this early epiphany, he developed a metaphysical conception of the artist as one who channels the images from his inner eye onto paper instantly, through an extraordinary effort of will. In a 1919 letter to the *New York Sun* he wrote:

For the last ten years my village of dreams lies right in my studio. I own an Aladdin's lamp which when I touch it allows my mind to be transported to any beautiful spot on earth; and then I paint the nook and scene in an hour's time. Thus my walls are replete with dreams and thousands of different views stand piled against the walls on the floor.[9]

In his 1920 talk he said: "Soul work is a conception, a vision. Blake[10] saw all the pictures he painted in his mind before he painted them. The realists must always have something before them." Eilshemius's understanding of painting as an autonomous reality beyond its representational function was part of his conception of the artist as a painter of visions: a metaphysician. After his revelation about the artist's will, he was never just a landscape painter or a visionary symbolist; rather, his visionary work was filtered through his love of nature, ultimately producing a deeper and more complex body of work.

By its date, *Mother Bereft* of 1888 (fig. 1) might have been painted at the end of Eilshemius's stay in Paris. How-

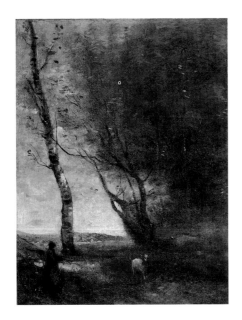

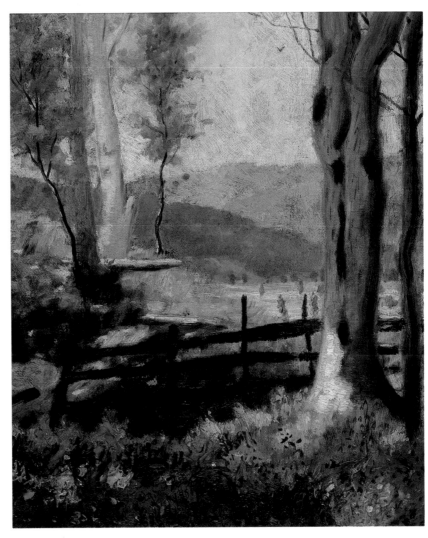

Above, fig. 2 Jean-Baptiste-Camille Corot,
La Chevrière au bord de l'eau, ca. 1860–65,
Private Collection

Right, fig. 3 *Edge of Woods*, 1891,
Roy R. Neuberger Collection (cat. no. 3)

ever, this picture of a model in an armchair, baring her breast, displays an intimacy that seems to go beyond the crowded rooms at Julian's. In this work, he followed the model of Corot's figure paintings, such as *Seated Women, Breasts Uncovered*, of about 1835–40, or *Blond Gascon* of 1850, which display a palpable emotional gravity constructed with deft painterly assurance. Eilshemius expresses a similarly abstracted quality of mood with less painterly modeling. Unlike his later invented images of women, this is a portrait of a specific individual. It mixes a fastidiousness of drawing around the face within an overall abstract composition. An atmosphere of sadness and resignation permeates the painting. Although we do not know who actually titled this work, it does bring up associations of Eilshemius's mother Cecilie, who lost three of her six children while still in their youth, including Louis's favorite playmate Victor (to whom he would later write a book-length poetic elegy).

As *Mother Bereft* illustrates the connection between Corot's and Eilshemius's figures, *Edge of Woods* of 1891 (fig. 3) underscores the connection between their land-

scapes. Eilshemius's picture has the fussiness of youth. The brushstrokes delineating the sky are carefully laid down in one direction. Similar directional strokes also delineate a patch of sunlight hitting the tree trunk in the foreground. Corot said that above all one must study values which are the basis of everything. Compared to a Corot woodland scene (fig. 2), *Edge of Woods* appears to lack the surety of Corot's tonal sense; yet it is appealing because of its slight awkwardness. It is the same aspect that gave *Mother Bereft* its humanity. In both works, we find our way to Eilshemius through his imperfections. They are like the dropped stitch in the Navajo rug that forestalls hubris. But Eilshemius's work cannot win us over solely on its awkwardness; he matches this with grace.

Village near Delaware Water Gap of 1896 (fig. 4) manifests the grace inherent in Eilshemius's work. He made several paintings of the landscape surrounding the Delaware Water Gap, which were among his most well received early paintings. The National Academy exhibited his *Delaware Water Gap* landscapes twice, and the Pennsylvania Acade-

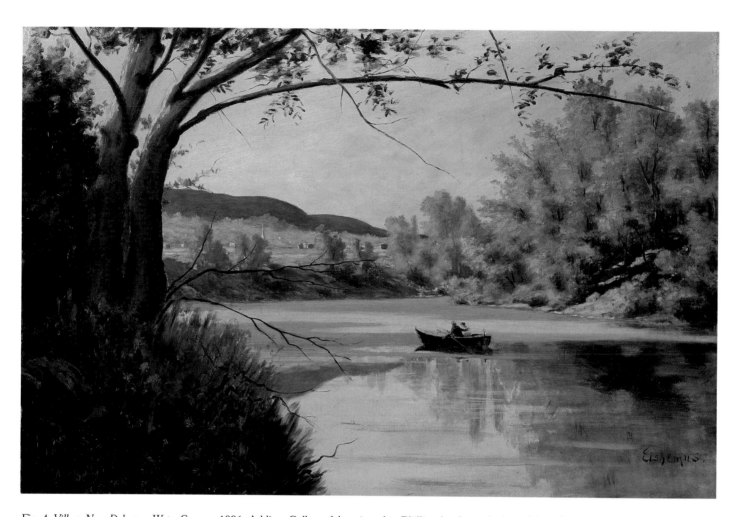

Fig. 4 *Village Near Delaware Water Gap*, ca. 1896, Addison Gallery of American Art, Phillips Academy, Andover, Massachusetts (cat. no. 5)

my of the Fine Arts accepted his paintings for exhibition from this series in 1890 and 1891. *Village near Delaware Water Gap* of 1896 presents a balance of space, color, and light. It reflects the blond palette and tonal clarity of Corot's Italian landscapes. The format of a lake framed by trees evokes Corot's *The Village and Lake at Como* of 1834 or *Lake Nemi through the Trees* of 1843. According to one report, Eilshemius advised American painters to learn from "the Italian School and French nineteenth century artists such as, Daubigny and Corot." This harmonious image of a couple rowing on a lake displays the synthesis of feeling and representation that George Inness speaks of when he states that, "Whatever is painted truly, possesses both the subjective sentiment—the poetry of nature—and the objective fact."[11]

The bucolic idylls of the Delaware Water Gap are followed three years later by one of Eilshemius's most arresting images, *Afternoon Wind* of 1899 (fig.18). Over a Barbizon-style landscape, six porcelain-white nude women float, hover, or vault through midair. They do not really fly but simply pose in midair, relaxing in zero gravity. *Afternoon Wind* has the power of a child's dream of being able to fly: it happens as if by magic. The women are like currents of wind circulating through the valley. William Schack, Eilshemius's biographer, relates that it was painted in Rome, that the "flying nudes . . . were suggested by the Renaissance masters surrounding him," and that Eilshemius was also "influenced by the landscapes of Poussin and Lorrain."[12] Paul Karlstrom has indicated some sources for paintings of women flying, notably Arthur B. Davies and Pierre Puvis de Chavannes. Yet, both of these painters displayed an essentially neo-classical vision of the figure, whereas Eilshemius's flying women are strangely contemporary. The straightforward manner in which he presents his vision was also entirely different from the florid literary symbolist painting of the period. *Afternoon Wind* is a protosurrealist image.[13] Eilshemius employs an almost illustrative technique to render inexplicable events. What would have made *Afternoon Wind* shocking if it had been exhibited at the time is that the flying figures are neither allegorical nor literary. No narrative reading is possible. In his 1920 lecture, Eilshemius explained his notion of idealism in painting, "The realistic part is there, but we imbue the realistic part with imagination and mystery." As is the case with much of his work, the magic comes as much from his complex organization of forms—here comprised of graceful arching diagonals—as from the unpredictable image.

The Dream of 1908 (fig. 13) depicts a ring of dancers in midair. Behind a grove of slender trees, past the side of a hill, five nudes float over a lake. The moon shines brightly over the valley. One woman seems to be stepping off the hill, as if the others are lifting her into flight. *The Dream* is a softer, more mellifluous painting than *Afternoon Wind*. The women are featureless: reflecting Eilshemius's idea that "You cannot get motion if you put in every little detail of the body."[14] The composition was worked up fully in a half-scale preparatory watercolor, entitled *Dance of the Sylphs* of 1908 (Newark Museum, New Jersey).

The bodies and postures of the dancers in *The Dream* resemble the figures in Matisse's *The Dance* of 1909. Matisse based *The Dance* on a section from his radical idyll, *Joy of Life* of 1905–06. It is possible that Eilshemius, who traveled in Europe in 1907, could have seen a reproduction of *Joy of Life*, which had caused an uproar in the 1906 Salon des Indépendents, because of its highly saturated color and primitive drawing. But, more likely, it is one of the remarkable synchronies that regularly place Eilshemius's work on a parallel track with that of a number of twentieth-century vanguard artists.

In a letter to the critic Henry McBride, about the artist Benjamin Kopman,[15] Eilshemius supported McBride's interpretation of himself as a visionary. He wrote:

A week ago I read your article on Kopman in which you place my name alongside of his and William Blake. Aye, I feel flattered, because I am a visionary when the mood dictates and have painted a number of subjects out of the air . . . one very mystical: "Demon of the Rocks"—and others. You say Kopman voyages to the upper spheres for his subjects. That is worthy of the artist. I've been resorting to such a habit since 1888 . . . let the works inspired by spiritual visions be praised.[16]

In this statement Eilshemius dates his interest in visionary art back to his revelation in Paris, attributing special significance to *The Demon of the Rocks* of 1901 (fig. 20). He included the work in a list of "Some of the Most Important Paintings," in his publication *The Art Reformer* from 1911. Most of the works on this list, which included *Afternoon Wind*, were fantastic subjects. *The Demon of the Rocks* portrays a malevolent demon with a poignant human face, which, as Paul Karlstrom has pointed out, bears a striking resemblance to Eilshemius himself. The demon floats in a chasm, holding a fiery staff. He is bodiless, with long flaming fingernails and horns. His head seems to emerge from a fiery beard. He hovers over two naked women whom he has trapped in a chasm. Strangely it is the demon that looks pathetic; the women simply react. This image is part of a long tradition of stories representing women held captive by

demonic entities, still so prevalent in film culture today. With the demon's "cowardly lion" expression, it is also like a comic opera version of one of Albert Ryder's wilder motifs, such as *The Race Track*.

Eilshemius was aware of and interested in Ryder's work. In a letter published in the *Sun*, he recalled visiting, in 1907, Ryder's studio on Fifteenth Street in New York. Eilshemius would have been forty-one and Ryder sixty. Eilshemius wrote:

> In 1907 I visited Ryder in his small rooms. I asked him how long it took him to paint one of his canvases. "You see it is best to take ten years to execute one subject." I laughed and told him I could do the trick in a few hours. "You must be the Devil," he shouted. Well, when I got back to my studio on Twenty-third Street, I painted my two paintings in one hour for each. Quite some energy! Selah[17]!

If the recollection is accurate, then Eilshemius painted *Macbeth and the Witches* and *The Flying Dutchman* (fig. 5), both of 1908, after seeing Ryder's paintings briefly in his apartment. This supports the importance Eilshemius placed on memory as a tool for the artist, in his lecture at the Société Anonyme. Ryder's process of slowly building up his paintings touch by touch was in complete contrast with Eilshemius's rapid attack. In Ryder's *Flying Dutchman*, the individual parts of the composition are subordinated within the whole swirling rhythmic mass. Eilshemius is like an opera director, allowing each element to stand out distinctly, like props on a stage. The sea crashing on the rocks, the tiny sailors, the cliffs, the negative and positive ships, and the passage of light from sea into sky are all carefully orchestrated shapes that echo and answer each other. The composition is built along a diagonal axis that hearkens back to Ryder's original version. The freedom of Ryder's compositions may have helped Eilshemius take a more radical direction in his work after 1910.

Ryder and Eilshemius shared a predilection for the urban nocturne. Lloyd Goodrich, in his book on Ryder recounts how, "On summer evenings when the moon was full, [Ryder] often took the ferry to New Jersey and walked most of the night, returning in the early morning. He told Alexander Shilling that on these walks he 'soaked in the moonlight.'"[18]

By the evidence of his work, Eilshemius also "soaked in the moonlight." Many of his greatest New York City paintings are nocturnes. *New York at Night* of 1908 (fig. 17) is a poem about illumination. A streetlight, a trolley light, and a distant glittering hotel sign are projected against a crescent moon in a blue night sky. Light scrapes the side of a building and hits the tiny walkers. The cardboard ground glows red through the blue sky.

Eilshemius's most majestic image may be *New York Rooftops* of 1908 (fig. 19). Similar in format to *New York at Night*, a dark silhouetted building on the left is juxtaposed against the rich color of the sky. Eilshemius's black shapes catch the generalization of form of city architecture after dusk. The colors are pitched around a scale of pink, yellow, blue, and gray. A star blinks. The space is exactly right—exactly articulated. Ralph Albert Blakelock, Eilshemius's contemporary, with whom he is sometimes compared, painted the shacks and shanties of New York in the 1870s; Ryder also drank in inspiration from the city; but in 1908, Eilshemius fashioned a singular tenebrous poetry out of the New York skyline, far removed from these two artists and from the proletarian hubbub of the Ashcan school as well.

Autumn Evening, Park Avenue (fig. 11) of 1915 is a harmony of black, warm orange-brown, and gray, with the majesty of a mournful threnody by Beethoven. The picture is achieved by almost impossible means. In this exemplary late period work, Eilshemius summarily indicates big mute building shapes with diluted oil paint on paperboard. The paint is so thinned out that the color of the support becomes a large part of the overall color. The warm color of the board infuses the night sky with orange glowing through the thin washes of white and gray clouds. A row of three slender trees snakes and curls upward like beanstalks. On the horizon, there is a far off sparkle of the lights at the end of Park Avenue, muted in the soft gray atmosphere of night. It is a metropolitan vision at once barren, tough, and yet strangely comforting. The ambivalence that Eilshemius felt in regard to New York as home is evident in this vision of the city. The isolation he personally felt is represented in his view of the city as a sparkling metropolis, largely uninhabited, a place for solitary evening walks. In his travels, Eilshemius sought a different perspective. His father's death in 1892 provided him with the means to travel, and he visited Europe, North Africa, and the West Coast.

In 1901, Eilshemius traveled to Samoa, seeking to paint nudes outdoors. He began by making delicate portrait drawings of young island women and watercolors of the landscape. He also photographed and purchased photographs of Samoan nudes. Intriguingly, it was not until 1907, five years after his trip, that he actually made the approximately twenty oil paintings that were based on this subject matter. Furthermore, these works were not exhibited until 1924, in Eilshemius's second exhibition at the Société

Fig. 5 *The Flying Dutchman*, 1908, Whitney Museum of American Art, New York. Gift of Gertrude Vanderbilt Whitney (cat. no. 20)

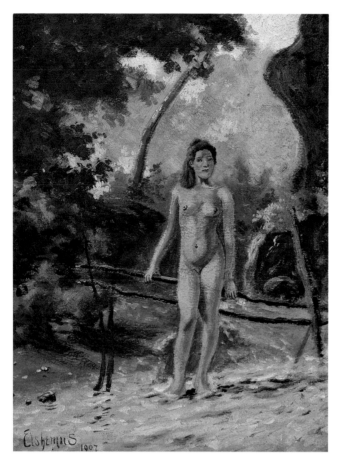

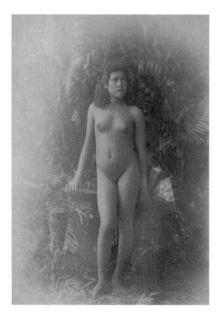

Top, fig. 6 *Samoan Nude Wading*, 1907, Roy R. Neuberger Collection (cat. no. 16)

Above, fig. 7 Unknown "Samoan Girl," photograph. Robert K. Fitzgerel Collection.

Anonyme. They were reviewed favorably by Henry McBride in the *Evening Sun*:

> There is the stir of perfumed air and the excitement of romance in each of these panels. It seems incredible that they should have reposed here in this town all these years unrecognized by expert opinion.[19]

The five-year gap between his trip and when he made the oil paintings raises questions about Eilshemius's process of oil painting in general. Some of his landscape paintings have an immediacy that suggests they were done *en plein air*. However, in his 1920 lecture, Eilshemius wrote that, "One must school oneself to memorize everything one sees on his way, that is why the mind is all filled with souvenirs and memories of what he has seen. When painting one recalls these things and can produce them on canvas."

Eilshemius's paintings of Samoa reflect the combination of the mental and actual snapshots on which he based them. These paintings seem to arrive through the haze of time. The centers of the canvases are focused, while the edges are slightly blurry and soft—like old photographs with a narrow depth of field. He based his painting *Samoan Nude Wading* of 1907 (fig. 6) on such a photograph (fig. 7), in which the figure stands in sharp focus against a soft blurred wall of foliage. In lieu of the flat background of the photograph, Eilshemius creates in his painting a complex open space around the figure. The figure supports herself against a wooden railing as she cools her toes in a pale stream of water. There is an unforced quality to *Samoan Nude Wading*; the awkward precision of the drawing around the hands and hip plays off the soft shapes of the forest in the background. The poignancy conveyed in the painting does not seem like the result of an artist working from a photograph. It is too intimate, too personal. It has all the strangeness of a real encounter between a thirty-five-year-old American artist and a young Samoan woman in the woods of Apia.

In *Samoa* of 1907 (fig. 8), Eilshemius translated the tonal modalities of Corot's French studio landscapes to a tropical atoll. The center of the image hovers in focus, while the jungle hillside dissolves into a warm middle tone. Many American artists who were influenced by Corot, such as Inness, Alexander Wyant, and J. Francis Murphy forged their own version of Corot's popular late landscape style—misty green landscapes with a few slender trees. Eilshemius, however, was influenced by all the different aspects of Corot's various styles—his early Italian "blond" landscapes, his figures, his outdoor nudes, and his misty green "souvenir" landscapes. Eilshemius was able to apply

Fig. 8 *Samoa*, 1907, Harry and Cookie Spiro (cat. no. 14)

his understanding of Corot's underlying tonal structure to a variety of landscapes and motifs.

Spanish Street (Malaga) of 1909 (fig. 9) has the blond palette of Corot's early plein-air Italian sketches. The elegant off-white harmony also resembles van Gogh's paintings from Paris and Arles or a Utrillo view of Paris. Terracotta-roofed houses overhang a tidy white street, paved for carriages. It is an afternoon world of women and children. The artist displays pleasure in painting a variety of complicated surfaces. In 1909, four years before the Armory Show, Eilshemius demonstrated a fluent understanding of the handling of paint by French artists. In *Spanish Street*, he employed a postimpressionist approach before Stuart Davis painted van Gogh-like scenes in 1916 or Marsden Hartley processed Cézanne in the 1920s. *Spanish Street* represents the full flowering of Eilshemius's pre-1910 landscape paintings. In discussing an exhibition that focused specifically on Eilshemius's paintings from 1909, Clement Greenberg wrote:

> Arbitrary though it might appear, no better selection of Eilshemius's work than his production of 1909 could have been made as a starting point for the re-evaluation of his art. . . . The year marks a critical station in the artist's career. The simplification of his later—or what I choose to call "deranged"—period, with its yellows, acid greens, oranges, tans and pinks, begins to emerge even as the comparative academicism of his earlier period reaches its fruition. We see that Eilshemius was a thin but very intense talent.[20]

Greenberg ends his review with, "Eilshemius became too radical. His painting was at its best when it retained enough of academicism to give it body, complication and control." But Greenberg added that despite his madness, Eilshemius was "one of the best artists we have ever produced."

By 1909, despite the maturation of his painting style, Eilshemius's work had gotten nowhere in terms of its public reception. In 1909 he exhibited fifty paintings in his East Twenty-third Street studio, in a show he titled "Painting in Three Colors." He stated that with three colors, he could produce any effect, "from the solemn tones of a Corot to the gorgeous explosive coloring of a Monticelli."[21] But the exhibition occurred in a vacuum: no serious audience for his work existed. He found attention only as a novelty, for instance, when the London journal *Sketch*, wrote about him as "The Most Versatile Man In The World."[22] In an attempt at wider self-promotion, he published a magazine

entitled the *Art Reformer*, and began to distribute handbills describing his manifold attributes. He also began the technical experiments that led to his late style.

UNPREMEDITATED PAINTING

The abstract idea is a frame which delimits,
a hole in the infinite. . . .

— Derain

In 1911 Eilshemius devised his "self-made frames," actually a frame he painted around the image, directly on the support. He had incorporated a simple painted frame around *The Flying Dutchman* of 1908, but now these frames became increasingly more elaborate. They allowed him to create an increasingly complex, more abstract space, as well as having the practical benefit of keeping the image away from the corners, thus protecting his work, which was mostly on fragile paperboard[23]. He increasingly painted on paperboard instead of canvas.[24] In a letter to a city newspaper, he claimed to have discovered a method for making gold (in truth, the "gold" of the painted frames). A reporter who visited his studio, seduced by Eilshemius's claims, described his paintings as: "Canvases of red moons rising on gnarled trees with hazy nude girls dancing forlornly in black shadows."[25]

Like Alexander Cozens and Victor Hugo who employed inkblots to anthropomorphic effect in their ink drawings, Eilshemius discovered pictorial possibilities in the by-products of unpremeditated painting. One day, observing the paper on which he wiped his brushes, he noticed that it was in "the several wipings, dabs and splashes, where I find a number of perfect pictures. Each I surround with a thick line, serving as a frame. Then behold! Two paintings like a Whistler, landscapes as though got from nature, and sometimes cities like Venice. To give life to some, I always draw in a figure or two."[26]

He announced his researches in a pamphlet advertising various strange inventions and techniques. He describes a "painting discovery." The artist sets out a limited palette and a piece of cardboard and "splashes" the paint onto the board "indiscriminately" seven times, after which, "You'll have a conglomerate series of spots and strokes put there without a thought. Then stand back three feet from that mess and *create* some fine decorative painting by combining spots, etc. with your *imagination*."[27] The "self-frames" he devised and his painterly distortions constantly call attention to his images as *paintings* rather than as mirrors of real life. After 1910 Eilshemius consciously moved away from

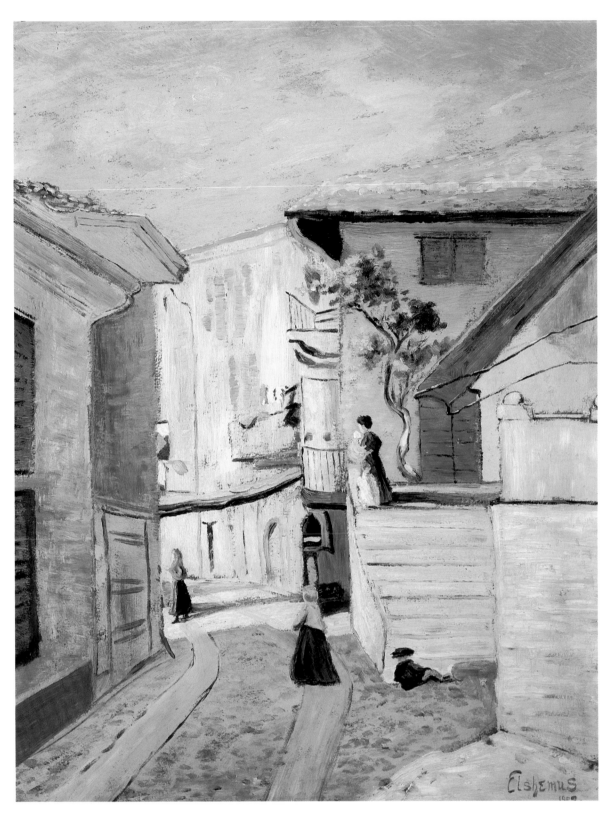

Fig. 9 *Spanish Street Scene, Malaga*, 1909, Robert K. Fitzgerel Collection (cat. no. 26)

Corot's tonalism into a more abstract terrain of signs, symbols and abstraction.

In 1913, Eilshemius submitted five canvases to the selection committee for the Armory Show. In what art historian Milton Brown later termed the committee's only major omission, Eilshemius's canvases were rejected. However, between 1913 and 1917, Eilshemius painted many of his largest and most ambitious paintings. They are uniformly on paperboard, often in large thirty by forty inch or forty by sixty inch formats, and they have come to define his late style.

It has commonly been assumed that the neglect Eilshemius suffered continued to undermine his morale and the quality of his work after 1910, until he finally gave up painting in 1921.[28] It is worth noting that he himself preferred his late paintings, such as *Man on Horseback, near Los Angeles* of 1916 (fig. 10), *Autumn Evening Park Avenue* of 1915, *Tragedy of the Sea (Found Drowned)* of 1916 (fig. 16) and *Self-Portrait* of 1915 (frontispiece), telling a reporter, "These are the masterpieces. These are my truly great work."[29]

It is also interesting to note that these four major paintings, and many others, were made after he was rejected for the most important and publicized modernist art exhibition of the early twentieth century—the Armory Show. Possibly this particularly egregious rejection actually pushed him to make some of the most ambitious and powerful works of his career.

Self-Portrait is keyed off the color brown—as are many of the late works. The warm yellow of the paperboard shines through the thin application of diluted oil paint. The artist gazes out intensely without distraction. It is hard to know whether he employed a mirror when he painted this work or perhaps worked from a photograph. The self-portrait strongly resembles photographic portraits of Eilshemius from this time. In any case, the result is a beautifully spare, spiritual portrayal. Eilshemius's head and shoulders float up toward the picture plane. His body has no substance. There is nothing here but the soul of the artist.

In *Man on Horseback, near Los Angeles* of 1916, he also lets the paperboard ground warm up the image. The rider making his way through a stand of trees on an empty road hearkens back to Corot (and even further to Hobbema). One recalls Karlstrom's observation about what Eilshemius took from Corot:

> The most important lesson Eilshemius learned from Corot was the very modern one of organizing a composition along the lines of formal abstraction. By

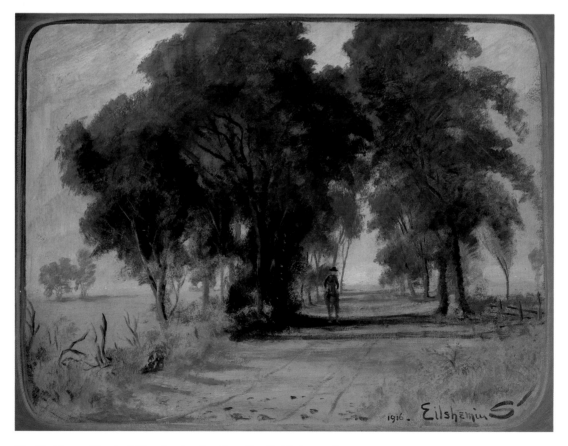

Fig. 10 *Man on Horseback Near Los Angeles*, 1916, Roy R. Neuberger Collection (cat. no. 37)

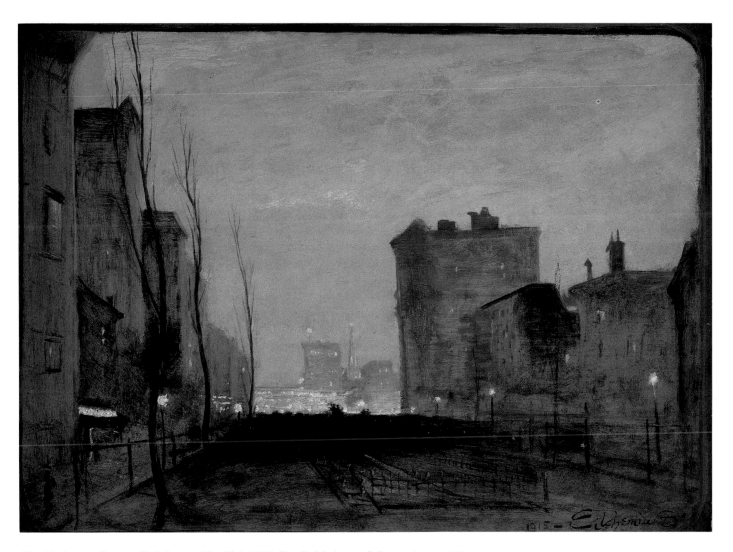

Fig. 11 *Autumn Evening, Park Avenue, New York*, 1915, Roy R. Neuberger Collection (cat. no. 31)

reduction and simplification, the fundamental features of a scene are presented in a way that emphasizes nature's patterns rather than its details.[30]

The central form is a group of trees summarily indicated in a masterly patch of olive green. He allows the brown ground to show through the foliage, lending nuance and depth. His painterly touch is at once cursory and authoritative. The painter Paul Resika once observed that Eilshemius had perfect tone, as a musician might have perfect pitch. It is Eilshemius's mastery of values—the gray scale between black and white—which lends *Man on Horseback* its wonderful solid form.

In contrast to the casual naturalism of *Man on Horseback*, the picture *Tragedy of the Sea (Found Drowned)* of 1916 is high opera. Two figures are center stage, on some rocks by the sea. The man lies draped over a rock, drowned. The woman raises her arms to the sky in grief. The air seems to push in around her, as she gestures defiantly. In this melodramatic composition the atmosphere is a tangible element of the drama. A mournful energy courses through the image. The bereaved woman grabs at our attention. It is a terrible, strange, tragic-comic confrontation with disaster. We are the helpless witnesses. Eilshemius's paintings from the period between 1913 and 1917 set the stage for the increasingly unpredictable events that followed.

THE INDEPENDENT

He was a true individualist, as artists of our time should be. . .

—Marcel Duchamp

I myself was certainly not impressed by the thing we all thought had impressed Marcel.

—Henry McBride[31]

Milton Brown described the exhibition of the Society of Independent Artists of 1917 as "the culmination of a long anti-Academic struggle," which united the liberal academic artists and the modernists on the platform of "No jury—no prizes."[32] The organizing committee for the independents included Marcel Duchamp, along with Walter Arensberg, George Bellows, Rockwell Kent, Maurice Prendergast, John Marin, Man Ray, Morton Schamberg, Joseph Stella, Walter Pach, and Katherine S. Dreier. Some 2,125 works by 1,200 artists from thirty-eight states were installed in alphabetical order, beginning with the letter R (which had been drawn from a hat)—Marcel Duchamp's idea for a

democratic installation. Two paintings by Eilshemius were included in the exhibition. The broad range of artists would have pleased Eilshemius, who in 1908 had written to several of the city's newspapers, suggesting that the National Academy of Design substitute the word "Private" for "National" in their name, because he considered it more of a club than a national organization. A tremendous internal row occurred before the exhibition had even opened. The debate centered on whether to accept or reject *Fountain*, a porcelain urinal that Duchamp submitted under the pseudonym Richard Mutt. After spirited internal debate between the Ashcan and the Arensberg factions, the organizing committee voted by a narrow margin to reject *Fountain*, which caused Duchamp to resign from the committee.

At the opening on April 17, Duchamp declared that there were two important works in the exhibition. One was Dorothy Rice's *The Clare Twins*, described as "a huge canvas, depicting two middle-aged, overweight, and distinctly ill-tempered looking ladies."[33] The other work that Duchamp singled out was Eilshemius's large *Rose-Marie Calling (Supplication)* of 1916 (fig. 12). Henry McBride wrote that while everyone agreed with Duchamp's praise of *The Clare Twins*, no one could understand what he saw in *Supplication*. As with many of Duchamp's activities, there are many interpretations of his actions. Calvin Tomkins, in his 1996 biography of Duchamp, suggested that while Duchamp was "certainly being facetious" about *The Clare Twins*, his support for Eilshemius was genuine. Beatrice Wood was with Duchamp at the opening of the exhibition and she recalled:

I was walking with Marcel Duchamp at the Independents and suddenly he pointed to a relatively small painting on a crowded wall and went over to it. It didn't happen to impress me and I was puzzled that Duchamp showed interest. When I asked why, he said that it was because that man was painting from his heart.[34]

A number of artists agreed with Duchamp, among them Gaston Lachaise, Charles Demuth, Joseph Stella, and Abraham Walkowitz. Some in the art world of that time, however (purportedly Georgia O'Keefe for one), considered Duchamp's avocation of Eilshemius to be a prank à la *Fountain*.[35]

In 1991 Thierry de Duve stated that "Eilshemius's rehabilitation was the exclusive and cruel work of Marcel Duchamp," implying that it was a trick on the older artist.[36] Looking at *The Clare Twins* (a truly grotesque image), it does appear that by advocating the two works, Duchamp

was continuing his assault on conventional standards, modernist or otherwise. However, after the exhibition, Duchamp continued to support Eilshemius's work, eventually attempting to arrange an exhibition for him at a gallery in Paris. This was unsuccessful, except for the fact that Duchamp ultimately left several paintings with his friend Henri-Pierre Roché in Paris.

The second issue of the New York Dada magazine *The Blind Man*, which was published by a group including Arensberg, Roché, and Wood, under Duchamp's guidance, included a report of a visit to the artist's studio, penned by the poet Mina Loy. Her piece is intriguing both as the first sophisticated critical response to his work and as an indication of the nature of Duchamp's appreciation for Eilshemius's work. She wrote:

> Wandering round the bountifully endowed studio we found such a variety of subject and treatment, as to give us some idea of the scope of the artist's mind. As Rousseau of the French spirit painted in France, does Eilshemius of the American spirit paint in America, with the childlike self-faith of a Blake. . . . His is so virginally the way a picture must be painted by one unsullied by any preconception of how pictures are painted, so direct a presentation of his cerebral vision, that between his idea and the setting forth of his idea, the question of method never intrudes. The complicated mechanism that obtains in other artists a prolonged psychological engineering of a work of art, is waived; his pictures, if one may say so, are instantaneous photographs of his mind at any given moment of inspiration.

Loy's last words are revealing as to the nature of Duchamp's interest in Eilshemius: "Duchamp meditating the leveling of all values, witnesses the elimination of Sophistication."[37] Duchamp had discovered a genuine and original American artist, yet by positioning him as an American Rousseau, he initiated a perception of Eilshemius as a kind of savant or primitive that has accompanied the appreciation of his work ever since. Duchamp, even if he missed the influence of Corot and other French painting on Eilshemius, understood that the coexistence of so-called primitive and of sophisticated tendencies in Eilshemius's work was a complex matter. In the catalogue for the Société Anonyme he wrote:

> Eilshemius cannot be called a "primitive" although his works show a "self-taught" quality—Like the primitives, he cares for an elaborate technique which fortunately, he never achieves- In his paint-

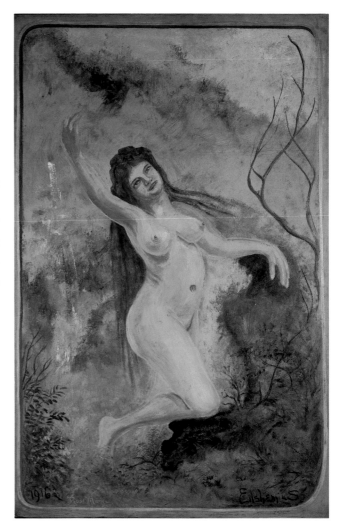

Fig. 12 *Rose-Marie Calling (Supplication)*, 1916, courtesy of Michael Werner, Inc.

> ings, built on a defiant drawing, never a doubt, never fear ever *barr (marr)* [sic] complete innocence. Out of time, landscapes as well as figures are foreign to any surrounding influence nor do they describe the period he lived in. Naturalistic in appearance and treatment his conception interprets a purely poetic brushstroke far remote from any theory or ism. . . . He painted like a primitive, but was not a primitive—and that is the origin of his tragedy.[38]

Duchamp reproduced *Supplication*, along with *Fountain*, in *The Blind Man*. The picture that had caught Duchamp's attention was described by the critic Henry McBride as a "faded, dingy, countrified Venus."[39] In his treatment of the figure, Eilshemius was surprisingly close to many of the international modernist interpretations of the human figure of that time. In this period, advanced artists consciously returned to tribal and archaic art as a source in order to fashion a human figure that was more raw, and more direct. Picasso's figures of his Rose period, the bold

simplifications of the *Demoiselles d'Avignon* of 1907, and *Biarritz Bathers* of 1918; Morandi's bathers from 1915, and Soffici's bathers from 1911 (which were themselves inspired by Picasso's *Demoiselles*); Derain's offbeat monumental figures from the years just before World War I, even Duchamp's own *Baptism* of 1911 (and related works) are all kin to *Supplication*. With hindsight, we can see how in 1917, Duchamp might have appreciated the power and crude intensity of *Supplication*, realizing that, in its own way, it was in sync with the advanced tendencies in international modernist painting. Duchamp clearly approached Eilshemius's work with a complex agenda. He knew that Eilshemius's work, with its awkward facture and strange imagery, had the power to provoke even sophisticated American artists. Yet Duchamp demonstrated an ongoing bond of support for the older artist, which was ultimately crucial to the reception of Eilshemius's work.

Unfortunately, Eilshemius was unable to parlay Duchamp's praise on the opening night of the Society of Independent Artists exhibition into a wider success. In June 1917, he staged an unsuccessful exhibition of war pictures in his studio.[40] Duchamp, however, continued to support him, bringing friends such as Henri-Pierre Roché and Katherine Dreier to Eilshemius's studio.

SOUL WORK

As he had not been shown except at the Society of Independent Artists for years—we were the door through which people's attention were again drawn to his work.

— Katherine Dreier[41]

In 1920 Katherine Dreier, upon Duchamp's suggestion, gave Eilshemius the inaugural one-person show at her new Museum of Modern Art at the Société Anonyme, which was located on East Forty-seventh Street. The exhibition presented sixteen paintings and ran for six weeks. As part of the pedagogic aspect of the exhibition, the artist gave "an informal talk" about his work on October 15, 1920. More than fifty people paid to hear him speak. William Schack stated that "he gave his talk—and didn't care to recall it in after years."[42]

Among the hundreds of letters that he published in New York newspapers and his many volumes of poetry and prose, this lecture is the most direct, succinct exposition of his ideas about painting. He begins the talk by dividing art into three camps: Realistic, Idealistic, and an intermingling of the two—seemingly identifying himself with the third camp. He differentiates between the realism of the academy

and imaginative artists—among whom he lists William Blake, George Frederic Watts, and (in one early typescript, which was subsequently disregarded) Dante Gabriel Rossetti. Eilshemius describes how he finds the monotonous repetition of academic realism as enervating as he did long ago at the Académie Julian. Great art is always original, neither slavishly replicating nature nor imitating artist's work. He believes that:

> Beethoven could not have existed if he copied other composers. When he started, he copied Haydn— his first sonatas were just imitations of Haydn. He said he will be himself, Beethoven. After that he composed real sonatas, and later on he composed symphonies, which are not imitative. Then we had a Beethoven.

The statement about Beethoven's "will" to become himself, relates to Eilshemius's own 1888 realization about the power of will as a divine imperative of the artist. Eilshemius continues the lecture by describing how he achieves an effect of motion in his pictures. This, he explains should be done by eliminating too much extraneous detail. It also involves using memory as a tool through observation to get to an essential image. He stated:

> The way to get action is to observe . . . people in motion . . . Observe how they move until all the motions are in your memory, and you can see them there without having any object before you. Then you can take your brush and colors and you know exactly what to leave out.

The sense of motion Eilshemius describes in his paintings recalls what the painter and teacher Hans Hofmann called "plasticity." Hofmann said, "A represented form that does not owe its existence to a perception of movement is not a form, because it is in this respect spiritless and inert."[43] The movement of the pictorial energy in his paintings was very important to Eilshemius. He tells about having consciously changed his work ten years before (in 1910) because he "wanted to express a symphony of lines . . . All the lines must convolute into each other, winde [sic] about each other, until every line goes to the center of the painting." This, Eilshemius believed, leads the viewer's eye to the center of the picture. The conscious decision that he describes is startling because the stylistic shift in Eilshemius's work around 1910 has generally been interpreted as a byproduct of his descent into mental illness. Actually, Eilshemius had developed a conception of picture-making that looked beyond the illustrative tendencies of much romantic symbolism, towards

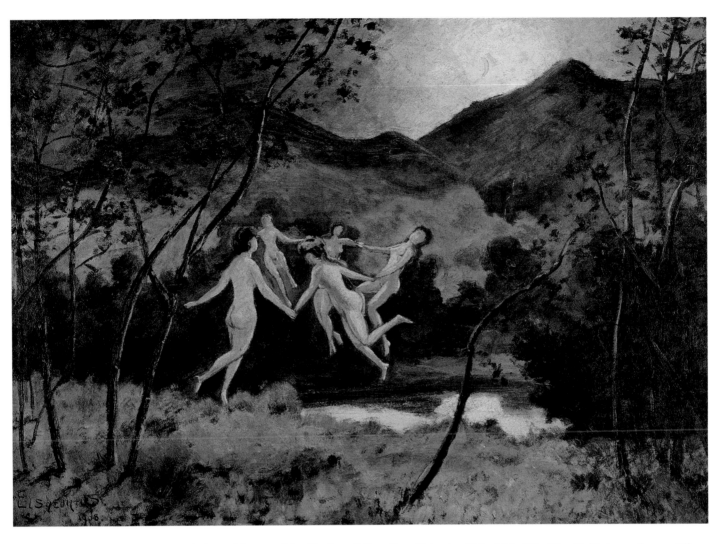

Fig. 13 *The Dream*, 1908, Collection Neuberger Museum of Art, Purchase College, State University of New York. Gift of Roy R. Neuberger (cat. no. 18)

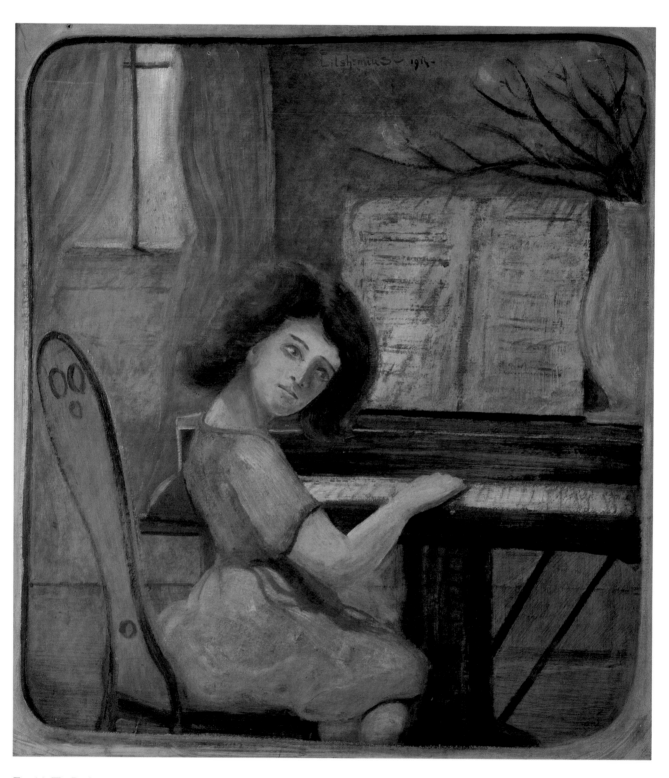

Fig. 14 *The Prodigy*, 1917, Private Collection (cat. no. 43)

abstraction. At the end of his talk he stated his credo: "Real art is painting, plus the introduction of soul quality . . . Whitman, Robert Browning—the only thing worthwhile in poetry is the soul quality of the author; otherwise it is prose." Eilshemius's emphasis on soul quality as paramount in his work may accurately describe what is most difficult to pin down about the appeal and importance of his paintings, but it is this elusive quality that appears through all of Eilshemius's paintings from the early landscapes to the late nudes, lending them depth that transcends their period.

Unfortunately, critics attacked his exhibition at the Société Anonyme because it lacked the "realism" that Eilshemius in fact disdained. W. S. Bowdoin wrote:

> There is no evidence that he uses a model from which to paint his nudes[44], and his landscapes are too often submerged in weirdness . . . *At the Piano* [also called *The Prodigy*] is another picture tainted by the Eilshemius brush and therefore provocative of anathema. [45]

One of the paintings which Duchamp had left with his friend Roché was *The Prodigy* of 1917 (fig. 14). In 1937 Roché wrote in a letter to Eilshemius's biographer William Schack:

> *The Prodigy* . . . represents a girl maybe eight years old playing piano, body in profile, while the face turned looks full at you. A most striking, somewhat frightening expression. The flowers on the piano, the chair are wonderful too. Many people have thought, seeing the picture of the heavy and glorious atmosphere of Edgar Allen [sic] Poe's poems. [46]

Roché mentions in his note how "several of the most promising young artists here appreciate them very highly," and how two young artists come particularly to see *The Prodigy* every year.

Recent research reveals that one of these "young artists" Roché mentions may have been the painter Balthus. *The Prodigy's* schematic furniture, the abstracted mood of the young girl, her odd expression, the curious and extreme curve of her neck, and its dry earthy palette all evoke the private worlds of young girls described in so many of Balthus's paintings. Scholars have assumed that in the period up to 1930, Balthus was generally uninterested in contemporary art, preferring the work of early masters such as Piero della Francesca and Masaccio. However, Duchamp reportedly told the New York art dealer Gertrude Stein that when Picasso first saw Balthus's work, he said, "You must have been looking at Eilshemius." [47] A

Fig. 15 Balthus, *Portrait of Sheila Pickering*, 1935, Private Collection, United States

footnote in the recent biography of Roché sheds further light on this connection:

> During a visit to Roché on April 19, 1930 (*Journals*), Madame Klossowska, accompanied by her two sons, Balthazar (Balthus) and Pierre, expressed to Roché their interest in the work of Louis Eilshemius, which hung beside numerous other paintings in the collection. Balthus, age twenty-two at the time, could well have been struck by the strange character of the work, which we recognize in many aspects (mystery, eroticism, primitivism) of his own painting. [48]

Balthus's mother, Elizabeth Dorothée "Baladine" Klossowska, who was a painter, a former inamorata of Rainer Maria Rilke, and a friend of Pierre Bonnard, had brought her two sons to Roché's house in April of 1930. At Roché's they would have seen several works by Eilshemius including *The Prodigy*.[49] This information provides new insight into the development of Balthus's work at this early stage in his career. In November of 1930, Balthus left Paris to perform his military service in Morocco. He was away from Paris for more than a year. Until he left, his work consisted of paintings of Parisian street scenes, portraits, and copies after historical works—which though they possess a measure of his vision, are as yet undeveloped. The Balthus scholar, Claude Roy states, "It was, curiously enough, at the end of these months of vacation and vacancy [his military service in Morocco] that the mutation appeared that was to bring out the true Balthus and make his work prior to 1932 seem in the nature of preludes."[50] On the back of *The Prodigy* is a penciled notation, "bought for Bala, 15 March, 1932" (Balthus returned from his military service in the

spring of 1932), which could indicate that right around the time of her son's return from Morocco, Baladine Klossowski may have planned to acquire *The Prodigy* from Roché, though ultimately the work remained in Roché's collection. In the years following 1932, when he returned from the service, Balthus found his definitive style in works such as *The Street* of 1933 and *Cathy Dressing* of 1933, *The Guitar Lesson* of 1934, and *The King of Cats* of 1935.

The head of the girl in Eilshemius's *The Prodigy* appears too large for her body and is turned at an impossible angle toward the viewer. This sidelong glance occurs in Balthus's paintings throughout his career: *Portrait of Sheila Pickering*, 1935, *The Golden Days* of 1944–46, *The Three Sisters* of 1955 or *Katia Reading* of 1968–76. Balthus was an artist who happily lifted from whatever sources pleased him—from Masaccio, John Tenniel, or William Hogarth. He has said, "Painters have used quotations just as much as writers."[51] While it is obvious that Balthus possessed his own sensibility as an artist when he was still in his childhood, it seems equally fair to say that his work changed definitively after he saw *The Prodigy* at Roché's home in 1930.

A PHENOMENON IN
AMERICAN ART

Of course I'm no society painter, I'm a bohemian and deal in ideal representations of nature like Turner or great symbolism like Blake.[52]

—Eilshemius

The negative response to Eilshemius's 1920 exhibition at the Société Anonyme was a final rebuke to an artist who for thirty-three years had sought in vain for the approval of the public and the National Academy. Exhausted from exposing his work to rancor and neglect, in 1921, he gave up painting. He was only fifty-seven years old, and the ostensible reason for his retirement was that the rent for his studio in the Sherwood Building had been raised from fifty-five to one hundred dollars. The Dada scholar Francis Naumann has pointed out that this was around the same time that Duchamp withdrew from making art, and that the younger artist, who had acted informally as Eilshemius's agent, may have influenced him by example. Ironically, by the time Eilshemius gave up painting, the process that would finally gain him the attention he had vainly sought for so long was in play.

In 1924 Duchamp and Dreier gave Eilshemius a second solo show at the Société Anonyme. This time, the works were selected from his pre-1910 period, including many of his 1907 and 1908 paintings from Samoa, and the work was received more warmly. The progressive critic Henry McBride experienced a "conversion." "Suddenly, like another St. Paul, I see a great light, and the scales drop from my eyes. The pictures in the Anonyme gallery are completely lovely."[53] Through this exhibition, Eilshemius found his first commercial dealer, Valentine Dudensing, who presented a one-person show of thirty-one paintings entitled, "A Phenomenon in American Art," at his Valentine Gallery. The critical response was generally hostile, with the *New Yorker* referring to it as the "nut-primitive school." But a new convert, Forbes Watson, wrote in *The World*, "The strange intangible spirit of these pictures arises from their combination or reality and spirit life."[54] However, the overall negative response dissuaded Dudensing from staging another exhibition for six years. The Valentine Gallery's two-part exhibition of 1932 was divided into pre-1910 works, which were termed "romantic drama" and later works, which were called "lyrical poetry." This exhibition generated a great deal of discussion in the art world. A group of artists published a letter in the *Sun* (which had regularly published Eilshemius's many letters) urging viewers to go see the paintings by "the one real creative and most individual painter we have in America today." Critics praised the work or reconsidered their previous dismissals. Eilshemius and Guy Pène du Bois got into a war of words in the pages of the *Arts Weekly*, when Pène du Bois suggested that Eilshemius was "primarily an artist with an appeal to people of jaded sensibilities madly seeking exoticisms, a Hindu restaurant in a slum or a picture devoid of traditional relationships."[55]

As a result of the attention, twenty-six paintings were sold, and Dudensing arranged an exhibition that summer in Paris at the Durand-Ruel Galleries. In Paris, the response was more positive than it had been in New York. Eilshemius was compared to Douanier Rousseau. Dudensing quoted Matisse as saying that Eilshemius was a "real painter." In the catalogue essay, Lionello Venturi took on the issue of Eilshemius as primitive. Referring to his supposed affinity to Henri Rousseau, he said: "This is pure nonsense, because Eilshemius was not a primitive, either true or false, but a great technician, a master of his means of expression, with a keen sensibility for the nuances of coloring."[56]

The Luxembourg Museum purchased *The Gossips*, the other painting by Eilshemius that had been included in the 1917 Society of Independents exhibition. The modicum of critical acceptance that began to greet Eilshemius's work

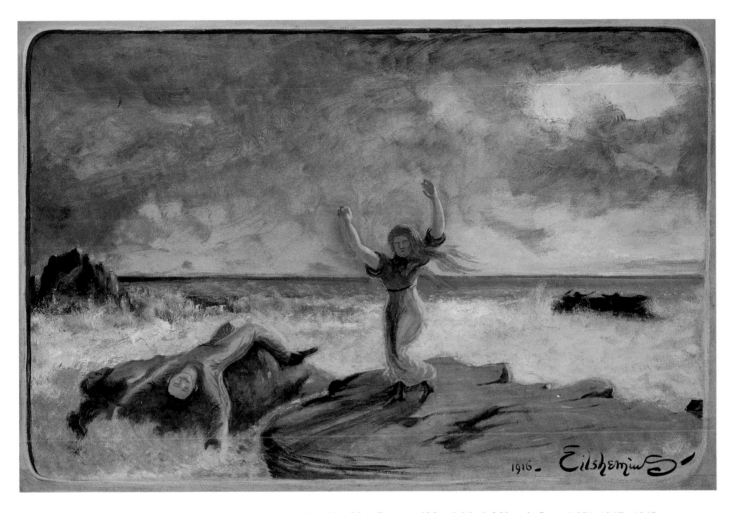

Fig. 16 *Tragedy of the Sea*, 1916, The Metropolitan Museum of Art, New York. Bequest of Miss Adelaide Milton de Groot (1876–1967), 1967 (cat. no 38)

also ushered in the most difficult period of his life. Incapacitated by an automobile accident in 1932, Eilshemius lived in constant pain, in what David Burliuk referred to as his "romantic castle," the family brownstone on East Fifty-seventh Street. Unfortunately, the family money had run out, and his brother Henry, who kept an office on Wall Street until he was eighty-six, was unable to ameliorate their circumstances. Eilshemius existed in a kind of twilight zone. Like Joe Gould, he was a popular bohemian figure in New York, whom artists including David Burliuk, Milton Avery, and Louise Nevelson loved to visit. Nevelson was directed to him by a guard at the Museum of Modern Art, who told her about his poor artist friend who lived alone and in pain in a brownstone on Fifty-seventh Street. She went directly to visit Eilshemius, and was entranced by him and his work, buying as many pictures as she could carry. She returned often, always purchasing paintings. Nevelson described how, in a gallery, she once witnessed Eilshemius commanding the figures in one of his paintings to stay seated. Rather than thinking him deranged, she admired how thoroughly immersed he was in the world of his paintings.

Late in his life, Eilshemius continued to besiege the world with correspondence. Because he was unable to walk after his accident, writing became his lifeline. He wrote numerous missives to Alfred Stieglitz, who he addressed as "Dear Famouser Stieglitz," "Dear Ami an Kamerad," "Dear Faustus Magnifico," and "Dear Frater Artes Superiores." Inveighing against the inequity of an art world that refused to support him, Eilshemius petitioned all who might listen for aid and succor.

He had some luck selling his work through Margaret Zimbalist at her Ten Dollar Gallery, for prices of ten to one hundred dollars. He was also the dupe of unscrupulous visitors who stole and bought work from him for a pittance. In 1939, in an early form of sophisticated art marketing, Eilshemius had three simultaneous one-man shows on Fifty-seventh Street, at the Valentine, Boyer, and Kleemann Galleries.

At the end of 1941, a year after his brother Henry's death, Eilshemius was unable to pay for medical support. Taxes on his home were $6,000 in arrears. A family housekeeper, who had worked for him for several years without pay, was bringing in food to help him survive. A fund for his assistance, raised by William Schack and others in the art community, was soon exhausted. Eilshemius was removed from his home against his wishes and taken to Bellevue Hospital, where he died of pneumonia on December 19, 1941. He wrote an obituary, attacking the critics who had neglected him. He signed it with a picture of the American flag, which he designated "his mark" and the quotation "I've not yet begun to fight." His obituary in the *Herald Tribune* was headlined, "Eilshemius, 77, Dies in Bellevue, Penniless, Bitter and Famous." The turnout for his funeral indicates how much his fortunes had changed in the art world of New York. Among those attending were Alfred Barr, director of the Museum of Modern Art, Edward Alden Jewell, art critic for the *New York Times*, John Bauer, curator at the Brooklyn Museum, Harry B. Wehle, curator of paintings at the Metropolitan Museum of Art, Henry McBride, Duncan Phillips, Arnold Friedman, Carl Van Vechten, Rockwell Kent, John Sloan, Moses and Raphael Soyer, and Chaim Gross.

In the years after Eilshemius's death, numerous exhibitions were devoted to his work. Important American collectors such as Duncan Phillips, Joseph Hirschhorn, Adelaide Milton de Groot, Stephen Clark, and Roy Neuberger acquired his work in depth, and gradually distributed many of his most important paintings to museum collections. Over the last fifty years, Eilshemius's work has been through cycles of attention and neglect. In 1970, the Sidney Janis Gallery mounted an exhibition entitled "The High Kitsch of Eilshemius," which focused on the late nudes and attempted to connect his work to a Pop sensibility.

In spite of these temporary vogues, Eilshemius has almost entirely been written out of the history of American painting. Marginalized as an eccentric, he exists in a historical limbo. Collectors such as Neuberger, Hirshhorn, and Phillips have kept Eilshemius's name alive, and artists are the ones who still remember him.

What artists have been able to see is that Eilshemius's "soul quality" is not just the manifestation of an eccentric visionary—this quality is equally evident in the graceful and complex organization of his forms. The way in which Eilshemius composes forms is the ultimate repudiation of those who see him as a "primitive." While he clearly appears to have suffered from a mental illness that William Schack characterized as manic depression, other major artists such as Johan Barthold Jongkind and Vincent van Gogh suffered similar illnesses. The shift in Eilshemius's style around 1910, which has up to now been judged largely as a byproduct of his weakening mental state, was, according to the artist, a conscious move toward a greater interpretive freedom of composition. We can speculate on the extent to which his illness influenced his work, but we must make a distinction between Eilshemius as an academically trained, unique, and sophisticated visionary painter, from what is called "outsider" art—though this distinction is ultimately a

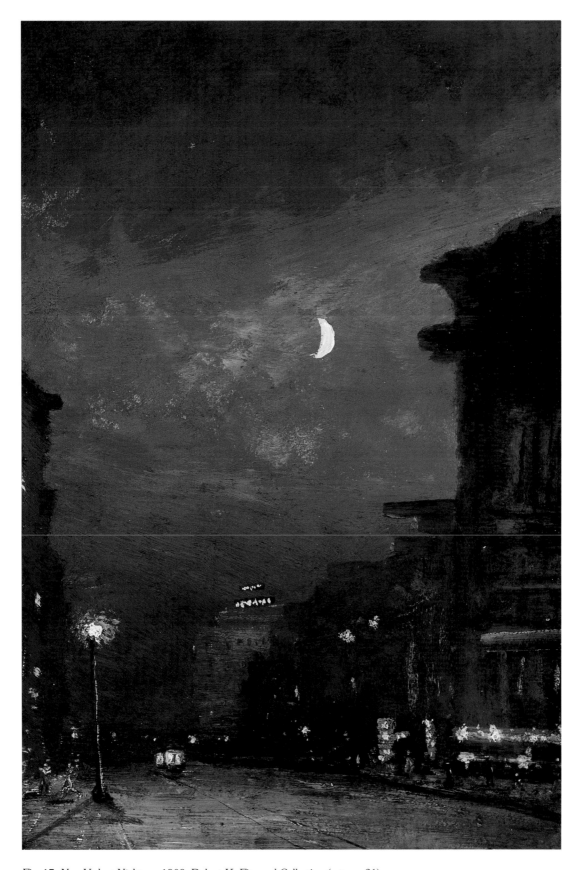

Fig. 17 *New York at Night*, ca. 1908, Robert K. Fitzgerel Collection (cat. no. 21)

false one. Both "outsider" and "insider" artists are left with the same problem—to make living forms, that successfully inhabit space. Eilshemius was not a folk artist—he was part of a modern lineage that began with Corot and continued through Derain and Balthus. Eilshemius's legacy is everywhere in contemporary art. Glimpses of the Mahatma can be found in John Currin's wizened odalisques and Marlene Dumas's tough children; in Elizabeth Peyton's blank-faced pop princelings and Henry Darger's armies of nubile child warriors; in Robert Greene's strange sylvan picnics and Paul Georges's angels and devils; in Malcolm Morley's battling biplanes and ships and Robert Yarber's figures zooming through space; in William Bailey's imaginary nudes and Paul Resika's early tonal landscapes; in the florid voluptuaries of Lisa Yuskavage and in contemporary culture's ongoing interest in the art, music, and writing of those we choose to call "outsiders." But Eilshemius says "phftt" to all of them. Who are these daubers and scribblers in comparison with him? He is the Supreme Parnassian, the Transcendent Eagle of Art, who was "a hundred years ahead of his time." He was a modern classical artist who demanded we work from the soul. He told us, "Let Art be free, Let it be as varied in subject and treatment as nature."[57] His work lived up to his own hyperbole.

Steven Harvey, June 2001

1 David Burliuk, "Eilshemius Fifteen Years Ago," undated typescript, Burliuk Papers, Archives of American Art, Smithsonian Institution, p. 1.

2 William Schack, And He Sat Among the Ashes (New York: American Artists Group, 1939), p. 281.

3 The author discovered a typescript entitled "An Informal Talk By Mr. Louis Eilshemius Given at the Museum of Modern Art, Societe Anonyme Inc. 19 E. 47th Street, October 15, 1920" in the Katherine Dreier Papers/ Société Anonyme Archive, Beinecke Rare Book and Manuscript Library, Yale University Library, New Haven. The full text appears on pp. 45–46.

4 Andre Derain, in an interview with Hillaire, quoted by Rosanna Warren, "A Metaphysic of Painting: The Notes of Andre Derain," Georgia Review 32 (Spring 1978), p. 108.

5 Intriguingly, Pierre Bonnard (1867–1947), Edouard Vuillard (1868–1940) and Paul Sérusier (1864–1927) also worked at Julian's at the same time as Eilshemius, but there is no evidence of them having known Eilshemius.

6 Quoted in Albert Parry, Garrets and Pretenders (New York: Covici, Friede, 1933), p. 119.

7 Louis M. Eilshemius, Mystery and Truth (New York: The Dreamer's Press, 1907), p. 4.

8 Eilshemius's belief in his ability to perform superhuman tasks of creation is an apparent display of mania that might accord with Schack's characterization of him as a manic depressive.

9 Quotation from a letter to the editors of The Sun, published January 9, 1919, headlined, "Louis the Villager." Original clipping from the collection of Robert K. Fitzgerel.

10 In an early draft of the typescript for the talk, intriguingly, the name (Ralph Albert) Blakelock, the visionary American painter and contemporary of Eilshemius, is substituted for Blake.

11 Nicholas Cikovsky, Jr. "George Inness: Sense or Sensibility", George Inness: Presense of the Unseen (Montclair, N.J.: The Montclair Art Museum, 1994) catalog organized by Gail Stavisky, p. 20.

12 William Schack's biography of Eilshemius, And He Sat Among the Ashes, remains the primary source of first-hand information about Eilshemius.

13 Afternoon Wind was reproduced in Charles Henri Ford's surrealist magazine, View in the January 1943 issue on the theme, "Americana Fantastica."

14 See here, An Informal Talk by Mr. Louis Eilshemius, p. 45.

15 Benjamin Kopman (1887–1965), painter from Russia who came to the United States in 1903. His early, dark, moody paintings somewhat resemble Ryder's. He later painted in a style recalling Rouault and Soutine.

16 Eilshemius to Henry McBride, April 28, 1935, quoted in Paul Johnson Karlstrom, "Louis Michel Eilshemius, 1864–1941: A Monograph and Catalogue of the Paintings" (2 vols., Ph.D. diss., University of California, Los Angeles, 1973), p. 172.

17 Eilshemius used the Hebrew word Selah regularly in his correspondence for emphasis. In Hebrew liturgical or musical direction Selah indicated a pause, rest, or interlude. Eilshemius's letter to the Sun about his visit to Ryder's studio is quoted in Paul Karlstrom, Louis Michel Eilshemius (New York: Harry N. Abrams, 1978), p. 49.

18 Lloyd Goodrich, Albert P. Ryder (New York: Braziller, 1959), p.28.

19 Henry McBride, "The Societe Anonyme Discovers Eilshemius," The Evening Sun, New York, April 19, 1924.

20 John O'Brian, ed., Clement Greenberg: The Collected Essays and Criticism (4 vols., Chicago: University of Chicago Press, 1986), Vol. 1, p. 166.

21 Quoted in Schack, p. 153. Eilshemius is referring to Adolphe Monticelli (1824–1886), French painter, most famous for his richly colored, thickly impastoed still life paintings that influenced Van Gogh and Cezanne. Eilshemius apparently meant multiple shades of the three primaries. A letter to the New York Herald published on March 21, 1909, states: "On my palette I use two reds—burnt sienna and geranium lake; yellow ochre and chrome yellow and any blue…— usually new blue."

22 Schack, p.164.

23 "Paperboard" is the conservator's term for cardboard.

24 Along with sheets of paperboard, in later years he also painted on such diverse materials as sheet music and cigar box tops.

25 Schack, p. 191.

26 Ibid., p. 212.

27 Eilshemius, Some New Discoveries in Science and Art (New York: privately published, 1932).

28 The death of Eilshemius's mother in 1911 is also supposed to have influenced the change in his work after 1910.

29 Schack, p.192.

30 Karlstrom, Louis Michel Eilshemius, p. 44.

31 Both quotations from Paul J. Karlstrom, "Eilshemius and Modernism", Louis M. Eilshemius: Selections from the Hirshhorn Museum and Sculpture Garden (Washington, D.C.: The Hirshhorn Museum and Sculpture Garden, 1978), p. 18–19.

32 Milton W. Brown, American Painting, from the Armory Show to the Depression (Princeton, N.J.: Princeton University Press, 1955), p. 66.

33 Calvin Tomkins, Duchamp: A Biography (New York: Henry Holt, 1996), p. 180.

34 Beatrice Wood to the author, April 15, 1995.

35 Georgia O'Keefe wrote to Paul Karlstrom that "Eilshemius was Duchamp's best joke on the art world" (letter to Karlstrom, November 29, 1977). See here, Karlstrom footnote no. 5.

36 Thierry de Duve, The Definitely Unfinished Marcel Duchamp (Cambridge,

Mass.: MIT Press, 1991), p. 202.

37 Mina Loy, "Pas de Commentaires! Louis M. Eilshemius," *The Blind Man* (May 1917), pp. 11-12.

38 Marcel Duchamp in *The Société Anonyme and the Dreier Bequest at Yale University: A Catalog Raisonné* (New Haven: Yale University Press, 1984), p. 257.

39 Schack, p. 211.

40 A review of his studio exhibition of war sketches from the *New York Evening World* of June 23, 1917, by William Goodrich Bowdoin, reads in part, "One of the spectacular pictures in the exhibition deals with 'United States Girl Scouts.' It shows the Amazonian trend in modern warfare. The girls in khaki, becomingly wear their military attire, and as painted appear well set up."

41 Katherine Dreier to William Schack, November 4, 1929, William Schack Papers, Archives of American Art.

42 Schack, p. 248.

43 Hans Hofmann, "Plastic Creation", from *Hans Hofmann* (New York: Harry N. Abrams, Inc., n.d.) introduction by Sam Hunter, p. 38.

44 It is unclear to what extent Eilshemius worked with models. Certainly, he worked from life in his earlier studio nudes, but by the period after 1910, it is obvious that many of his paintings of women came from his mind's eye, popular sources or earlier drawings and studies.

45 Schack, p. 249.

46 H. P. Roché to William Schack, December 12, 1937, William Schack Papers, Archives of American Art.

47 Gertrude Stein in conversation with the author, February 2001.

48 Scarlett and Phillipe Reliquet, *Henri-Pierre Roché: l'enchanteur collectionneur* (Paris: Éditions Ramsay, 1999), p. 102, n. 2, translated here by Paula Hornbostel. The author wishes to express his gratitude to Francis Naumann, who directed him to the Roché biography.

49 In a letter to Schack, Katherine Dreier lists the works by Eilshemius left with Roché as *Waiting for the Party, The Pool, The Morning Dip,* and *The Prodigy.*

50 Claude Roy, *Balthus* (Boston: Bullfinch Press, 1996), p. 64.

51 Ibid, p. 256.

52 Eilshemius interview, *New York World-Telegram*, cited in Paul Johnson Karlstrom, "Louis Michel Eilshemius, 1864–1941: A Monograph and Catalogue of the Paintings" (2 vols., Ph.D. diss., University of California, Los Angeles, 1973), p. 292.

53 Quoted in Karlstrom, *Louis Michel Eilshemius*, p. 36.

54 Shack, p. 263.

55 Ibid., p. 272.

56 Lionello Venturi, quoted in the exhibition catalogue *Masterpieces of Eilshemius* (Artists' Gallery, New York, 1959), opp. No. 12.

57 *Art Reformer*, 1, No.1 (1909), p. 2.

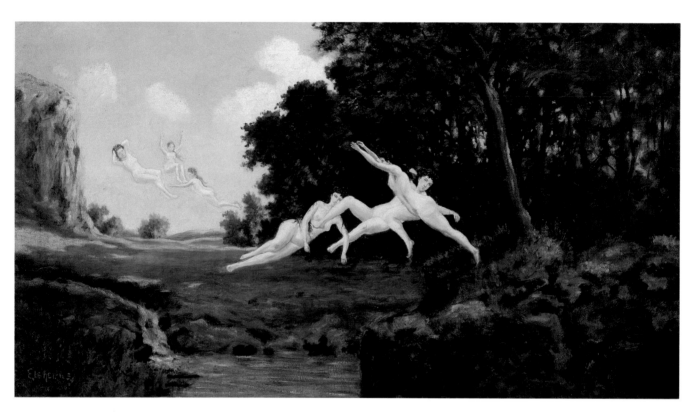

Fig. 18 *Afternoon Wind*, 1899, The Museum of Modern Art, New York. Given anonymously, 1941 (cat. no. 7)

Eilshemius Redux

Almost a quarter of a century ago, I wrote a monograph on Louis Michel Eilshemius. The same year, 1978, I was the curator of an exhibition at the Hirshhorn Museum and Sculpture Garden and author of the catalogue essay entitled "Eilshemius and Modernism." But it is now apparent to me that at the time I did not fully appreciate the nature of Eilshemius's relationship to modernist art, nor did I understand the ways in which his life and art could serve to enlarge the concept of modernism to include that which we now accept as defining.[1]

My approach was formalist, based on the critical method we were taught in the 1960s. At that time we felt obliged to incorporate the dictum of Clement Greenberg and others that modern art was an inexorable march to pure abstraction. For Greenberg and his disciples, non-objectivity and acknowledgment of the physicality, the material reality of paintings, signaled significance in contemporary art.[2] Therefore, to give Eilshemius importance, I developed an interpretation of his work that neatly charted a course from nineteenth-century narrative and landscape realism, in the manner of George Inness, Camille Corot, and Gustave Courbet, to a proto-abstract expressionism in which elements are reduced to a kind of formal shorthand for nature. Eilshemius's reductive, caricature-like treatment of his nudes, for example, or his marvelous and sensitive simplification of New York City views (figs. 11, 17, 19), suggested just that sort of expressive modernist progress.

Works such as *Dream Landscape* of 1919 (Roy R. Neuberger, New York.) or *Rivulet* of 1911 (The San Diego Museum of Art) could be seen as evidence of the artist's consistent, if intuitive, attraction to the abstract. The flattening of space, generalizing of form, arbitrary color, and emphasis on paint appeared to me to be a response, from about 1910, to modernist developments. In this view I now believe I was mistaken. And the years that have passed since I tried to bring to my subject the kind of dignity of purpose that seemed then to attach itself almost exclusively to those involved in the high modernist "enterprise" have allowed me to stake a claim for Eilshemius on his own terms. Whether Eilshemius's art represents an alternative form of modernism, something I have come to believe, or is simply a mar-

velously personal and expressive form of traditionalism, the fact remains he was a fascinating artist with a unique vision. He remains worthy of our attention and deserving of a more secure niche in the history of American art.

It appears to be the fate of some artists to remain in critical limbo, to appear at times ready for entry to Olympus, only to be flung back to await another and perhaps a final reckoning. This seems to be the case with Louis Eilshemius, "rediscovered" many times but still denied the immortality that is his due.

So wrote Abram Lerner, director of the Hirshhorn Museum, in his Foreword to the 1978 exhibition catalogue. Eilshemius has indeed suffered more in this respect than most artists, both during his lifetime and in his posthumous reputation. Discovered at the 1917 Society of Independent Artists First Annual Exhibition by Marcel Duchamp who with Katherine S. Dreier gave the artist two solo shows at the Société Anonyme in 1920 and 1924, embraced by the New York avant-garde, championed by influential New York Sun critic Henry McBride, collected by Duncan Phillips, and finally the subject of an appreciative 1939 biography entitled *And He Sat Among the Ashes*,[3] Eilshemius received more attention than the great majority of his contemporaries. In 1939 he had three simultaneous exhibitions in New York City, probably something of a record for a living artist. Between 1932 and 1941, the year of his death, he had twenty-five one-person shows in New York, hardly the profile of an unsuccessful artist. But that was not enough for the bitter, frustrated, and emotionally damaged artist who, in despair, had stopped painting in 1921. For Eilshemius it was too little and too late. That was his sad life story as chronicled by William Schack in the 1939 biography. But the art, at its best, transcended frustrated ambitions, turning into poetry the debilitating and alienating series of disappointments that constituted his personal and professional life experience. That is where the subjective "modernism" of Eilshemius truly resides—in his expressive distortions, not in the purely formal qualities of the paintings.

So, how do we place Louis Eilshemius? What is the work really about? Where does it come from? What are the authentic sources? What is his contribution? These are the fundamental questions. But in the case of this artist they are complicated by his ambiguous position as defined by the art market. Mercifully, Eilshemius cannot track the curve of his own career as reflected in auction sale figures. Despite the fact that his name continues to appear in histories of American art,[4] his works seldom bring more than four figures. Even works that could be described as among Eilshemius's best creative efforts (and numerous bad works remain from the hand of this very uneven and un-self-critical artist) seldom bring the minimum that even third-tier American *plein-air* paintings can command in today's market. Yet most major museums have Eilshemius works in their collections, although not often on display. He is well represented in the collections of the Metropolitan Museum of Art, the Museum of Modern Art, and Whitney Museum of American Art in New York, at the Neuberger Museum in Purchase, in Washington at the Smithsonian, and especially The Phillips Collection, with what should be ranked among the choicest gathering of his work, the result of Duncan Phillips's eye and taste.

In fact, Eilshemius has always been an artists' artist, one whose expressive vision is admired and appreciated by his peers—at least those who were openly seeking new ideas and forms. Among his friends and supporters were some of the leading figures of the New York avant-garde. In addition to Duchamp and Dreier, there were Henri-Pierre Roché, David Burliuk, Milton and Sally Avery, Abraham Walkowitz, Joseph Stella, Gaston Lachaise, Charles Demuth, Louise Nevelson, Alfred Stieglitz, Carl van Vechten, possibly Marsden Hartley, and (at least at one time) Georgia O'Keeffe.[5] He was collected by writers and musicians, including the well-known interpreter of Vivaldi, violinist Louis Kaufman. Kaufman and his wife Annette visited Eilshemius in his last years and gathered a significant private collection of his work, the source of several important recent gifts to leading museums and college galleries. The publisher Harry N. Abrams and Jean Lipman, longtime editor of *Art in America*, and her husband Howard, both pioneering folk art collectors, were among the early Eilshemius collectors.

Among a younger generation there are a surprising number of Eilshemius artist fans, including the artist Ed Ruscha who explains Eilshemius's appeal to him in terms of complete originality. "I look at Eilshemius's art and I see pictures that can almost exclusively be identified as his alone, unrestrained by any obvious influences. His work is often uncomfortable to look at and not meant to soothe the eye or mind. In this respect he is a complete original."[6]

Eilshemius seems to be especially interesting to those artists who came of age during the period of 1970s neo-expressionism. Often bearing the sobriquet "bad painting," the phenomenon was one in which awkwardness, naiveté, and direct personal expression were seen as virtues, subverting lingering notions of both the beautiful and overly cerebral or refined formalism. Among the leading exponents of this aesthetic were Charles Garabedian, Joan Brown, and New Image painters Neil Jenney, Lois Lane, and even (actually especially) Eric Fischl. The intriguing possibility of a still more complex and psychologically revealing connection between Eilshemius's imagery and that of Balthus is reinforced by new evidence.[7]

Eilshemius's work was taken up at different times for different reasons, and in that respect was a bellwether of current attitudes and enthusiasms within the modernist community. The Eilshemius vogue of the 1930s was aligned with a taste for the primitive, which for the modernist had less to do with folk art than with the supposed authentic and direct transcription of experience by the untrained and presumably unsophisticated (in other words, those rare artists whose vision remained unspoiled by contemporary urban life). This view was largely off the mark in the case of the academically trained Eilshemius, but that did not seem to bother Duchamp or others of the avant-garde who celebrated his purity of creative vision. They saw him as uniquely American, unspoiled by European cultural ideas of what art should be. The irony is that Eilshemius believed he was painting according to these timeless European cultural values, and with a competitive eye trained directly upon his immediate nineteenth-century predecessors as well as the old masters themselves. Seldom did his contemporaries receive a kind word. Picasso, for example, was the subject of his indignant derision. In terms of modernism, Eilshemius was an uncommonly obstreperous and recalcitrant fellow traveler. If he was a modernist, he was a reluctant and unwilling one.

At one time among the best known and, as we have seen, critically acclaimed artists in the United States, Eilshemius continues to provide an unusually instructive case study of the complications involved in making modernist connections in work that otherwise eludes categorization. Academically trained in New York and in Paris, he nonetheless drifted about as far from traditional pictorial aesthetics as any artist working at the time and this was despite his self-image as the champion of artistic and cultural tradition. Still, he repeat-

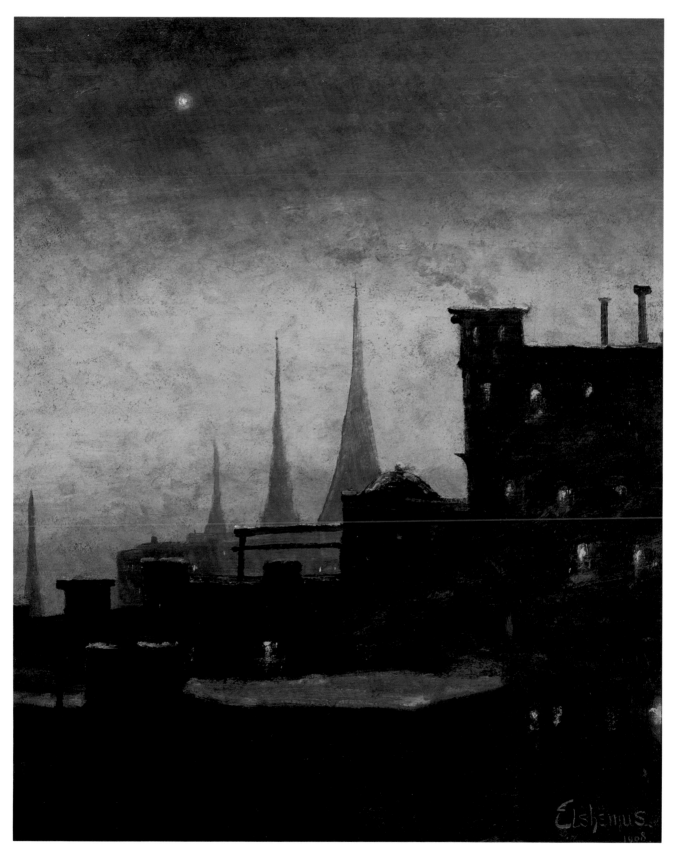

Fig. 19 *New York Rooftops*, 1908, The Phillips Collection, Washington, D.C. (cat. no. 22)

37

edly declared his unique position as the "Mahatma" of contemporary art. Especially in his later work from about 1910 to 1921, the year he all but abandoned painting in despair, he created in art what amounted to a private realm to which he would repair when his many disappointments about how he and his work were received were more than he could bear. This alone does not qualify Eilshemius as a modernist or his eccentric paintings as genuine expressions of modernism. In fact, he vociferously objected to modern art styles that he believed were undermining traditional artistic values. Nonetheless, the New York avant-garde promoted him for specific qualities that were understood to lie at the core of the modernist enterprise—and most critics were eventually won over. Herein lies the fundamental contradiction, the dilemma, in casting Eilshemius as a modernist poster boy.

What was the nature of all this somewhat unexpected appreciation, and what does it tell us about the changing face of modernism as viewed through a twenty-first century critical lens?

Much of the discussion and debate around modernism has had to do with stylistic and formal considerations, and these inevitably informed what was written about Eilshemius despite the difficulty of finally matching his work to such models. It is true that as in post-impressionism and early twentieth-century modernism there is in Eilshemius a consistent tendency to shallow space, simplified form, flat-pattern design, and arbitrary color, all deployed in the service of personal expression. In certain extreme examples, expressive stylization is carried to the point of decorative abstraction, another indicator (and in the view of some earlier critics, the formal goal) of modernism. However, despite the presence of these modern elements, they are overwhelmed by traditional picture-making devices. It seems more likely that for modern critics and artists the strength of the art was its pronounced individualism and evident freedom from accepted standards, not its specific subject, style, or form from the standpoint of conscious expressive means.[8]

It is tempting to cast Eilshemius's art exclusively in terms of psychology and subjectivity, but that would be an oversimplification. He occasionally expressed himself on the subjects of artistic methods and goals, what we would now call "practice." Especially interesting in this regard is an informal talk he gave in 1920 at the Société Anonyme.[9] We learn from the transcript something about an Eilshemius philosophy of art, at least at that particular moment. In describing the elimination of detail as a means to achieve "motion," Eilshemius further locates himself in the modernist camp by asserting that, "that is the difference between

academic painting and modern art."[10] How does this new identity square with the artist's previous self-conception as a staunch upholder of traditional artistic values? I suspect that opportunism played some role. Savoring the admiration and support of Duchamp, Dreier, and the avant-garde in general, and praised by critics as an "authentic American modern," how could Eilshemius, famished for attention and approval, do otherwise? And, of course, the talk was presented at the Museum of Modern Art, Société Anonyme. Eilshemius clearly had found a new artist community with which to identify.

As we have seen, those attracted to Eilshemius were uniformly sympathetic to modern art. Traditionalists were inclined to find him lacking in refined technique, inept in his observation of the fundamental rules of academic art: another irony in light of his conservative leanings and ambitions. At the core of the prevalent concept of modernism was a firm belief in total artistic freedom and spontaneous expression. And the interesting paradox of this thinking was that those who theorized knew that they were incapable of achieving the very qualities they posited. So, they needed to create a surrogate to stand in for them. Eilshemius was such a surrogate, the expression of the otherwise unrealized creative desires of the modernist community. Eilshemius embodied in his life and work something the most advanced artists sought. It mattered little that he had no idea what that might be.

Related to this appreciation of subjective expression was a growing respect for the liberating innocence of childlike vision, two concepts that recall aspects of surrealist philosophy and a basic attitude underlying much modern art. Obviously, such shifts in perception made possible by modernist thought were largely responsible for the positive attention Eilshemius eventually received. Duchamp visited Eilshemius in 1917 with the poet Mina Loy, who published the following account of their visit:

As Rousseau of the French spirit painted in France, does Eilshemius of the American spirit paint in America, with the child-like self-faith of a Blake . . . between his idea and the setting forth of his idea, the question of method never intrudes . . . his pictures are instantaneous photographs of his mind at any given moment of inspiration.[11]

This understanding of a basic principle underlying the modernist quest, most likely presented in Duchamp's own words, is quite different from one emphasizing either formalism on the one hand or, on the other, the cerebral investigation of representation and reality, art and language, associat-

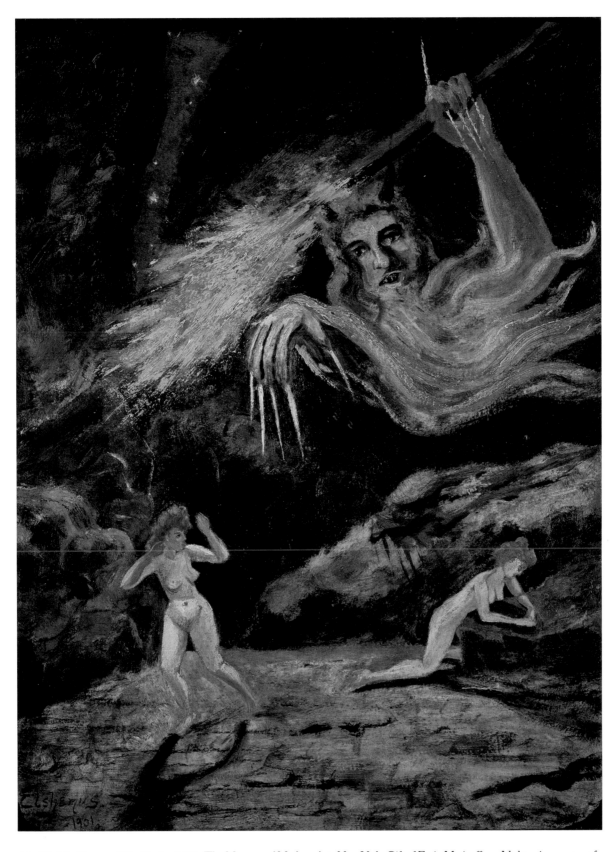

Fig. 20 *The Demon of The Rocks*, 1901, The Museum of Modern Art, New York. Gift of Fania Marinoff van Vechten in memory of Carl van Vechten (cat. no. 9)

ed with Duchamp himself. It is precisely at this juncture that the modernist conceptual frame extends to embrace phenomena and expression well beyond the mainstream, endowing them with significance that they did not previously have. Outsider art is a prime example. A *New York Times* review of last year's exhibition of works by the insane from the Prinzhorn Collection, entitled "Where Insanity and Modernism Intersect," suggests just how far we are now willing to go in our efforts to better appreciate the complex permutations and inflected nature of modernist art.[12]

So, despite my own earlier inclination to align Eilshemius with modernism through stylistic analysis, notably of the abstraction in the latter works, I now believe that these familiar and once almost exclusive measures of modernist sensibility are often secondary indicators. They are among the features that point in the direction of modernism, but they do not define and they certainly do not encompass or delimit it. For me, and especially in connection with artists such as Eilshemius, far more compelling is the psychological dimension. The art of Eilshemius is indelibly stamped with a frequently disturbing aura of self-revelation. The works were entirely about him and his own desperate lifetime struggle to find his place in a complex, indifferent, and seemingly arbitrary modern world, one dramatically changed from the mid-Victorian era into which he had been born. His experience, as mapped by his art, was that of loneliness and isolation, aspects often related to the modern human condition. Focus on the interior self, sexual obsession, and neurosis are qualities of modernity that fully infuse the art of Louis Eilshemius.

When we recognize the self-portraiture in *The Demon of the Rocks* of 1901 (fig. 20), we can see the extreme degree to which this is the case. Repeatedly rejected by the women whose company he so desperately sought, Eilshemius asserted power over them in and through his art by giving his own features to the threatening (and sexually potent) demon. Examples of this theme abound in the artist's work. Among the more disturbing examples are *The Rape* of 1910 (formerly collection Howard and Jean Lipman); *Early American Story* of 1908 (Philadelphia Museum of Art) in which barebreasted white women, one nursing a child, are threatened by a hostile native American with raised tomahawk; and *American Tragedy: Revenge* of 1901 (cat. no. 8). In the latter work, Eilshemius takes his own revenge by shooting a woman in the back with a rifle. In my mind there is little doubt that this, too, functions as a psychological self-portrait. And *The Rape* may just possibly serve a similar purpose by depicting a black male figure, the image of a despised outsider, ravishing

a pale white woman. To what extent might Eilshemius identify with the naked dark figure condemned by society to use force to gain access to a desirable (white) female? And of course there is *Othello and Desdemona* of 1900 (Hirshhorn Museum and Sculpture Garden, Smithsonian Institution), another representation of the wages of (perceived) betrayal and irrational envy. I suspect that Eilshemius may have even forgotten that Desdemona was innocent, the victim of Iago's strategic deception.

It may be that Eilshemius's experience of women, and thus, his representation of them, is the central and most revealing thematic aspect of his art. It seems to me now that Eilshemius defined himself as much by his frustrated desire for female companionship, the romantic attachments for which he longed, as by his art. Or, better still, perhaps the two were so joined as to form equivalencies. And in both areas he was, sadly, a failure. Almost everything else, including the course of his art, follows from that growing recognition. This approach could very well lead to the most productive study of the artist, a paradigm of the role that desire and longing can play in creative activity and the use of images to bring some sense of agency to insuperable reality.

In my view, now as well as then, the key to the understanding of Eilshemius's art is his relationship to women—a kind of metaphor for life—and his enormous, almost always frustrated, desire. And an important part of this is the Victorian dichotomy of the virgin and the whore. Eilshemius sought an alternative to this socially imposed limitation, as did Gauguin earlier, in the South Pacific, where Eilshemius visited in 1901. But the conflict for Eilshemius was that he was far from bohemian in his attitudes toward women: his poetry and other writing display romantic and conventional ideas about how women should behave. Finally, he was seeking the virgin, not the whore. Rose-Marie, a subject for his paintings and poems, is a key concept (with Eilshemius concept seemed to loom larger than actual person). His simultaneous love and hate for her, whether or not she actually existed as an individual woman in his life, motivated and infuses the several paintings entitled *Rose-Marie* and at least one revealing poem dedicated to her. It would seem that Eilshemius's desires, expectations, and finally much of his art were increasingly outside of his control. Consequently, his social behavior and the invented imagery in his paintings were affected, often dramatically. But that situation is exactly what provides the intense emotional energy, and its direct pictorial expression, that many astute and thoughtful observers have responded to in the work.

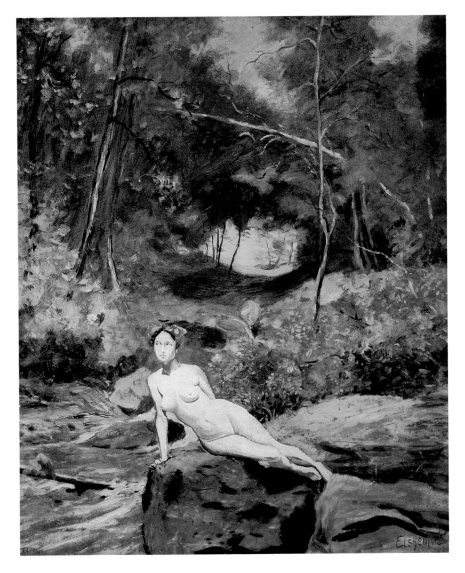

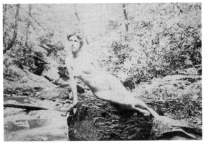

Left, fig. 21 *Afternoon Rest*, 1907, Robert K. Fitzgerel Collection (cat. no. 12)

Above, fig. 22 Unknown woman, photograph. Robert K. Fitzgerel Collection

Perhaps the most enlightening study of Eilshemius would be his models and his relationship to them as individuals. What was the role they, much more available than the girls he met at summer resorts, played in his life. We will probably never know the answer, but it seems unlikely—despite the sexual availability of many models of the time—that Eilshemius enjoyed the full advantages of the erotic potential of studio art practice.[13] However, the models (real or imagined), and the generalized idea of woman they contributed to, became in his art a kind of invented community in which he waged his life struggle. This line of investigation has been picked up and productively extended by feminist art historian Catherine Chastain.[14]

One supposes that many of the early nude groups, including those encountered in the great *Afternoon Wind* of 1899 (fig. 18) and *The Dream* of 1908 (fig. 13) with their liberated women defying the laws of gravity, were based on studio sessions involving multiple models. There are ample preparatory sketches and watercolors to indicate that Eil-

shemius worked from life as well as, especially in the later years, memory and imagination. This practice of working from life seems to have stopped around 1910, the year of his stylistic change. However, the situation is complicated by two recently uncovered photographs of nudes, one in a studio setting and the other apparently posing *en plein air*. (figs. 7, 22). They are the immediate sources, the true models, for *Afternoon Rest* (fig. 21) and *Samoan Nude Wading* (fig. 6), both from 1907.[15] They appear to be studio-produced commercial art photographs available for purchase, related to the erotic cigar trade cards and stereoscopic images Eilshemius probably also referred to for specific poses. For a traditionalist, he seemed quite comfortable with popular culture. In any case, there is little evidence that the artist himself took photographs to record live models, posing in or out of the studio, as part of his practice.

About one-third of Eilshemius's total *oeuvre*, perhaps as many as one thousand paintings, consists of female nudes.[16] I suspect that he produced more images of

unclothed women than did any other American artist, at least of his time. And, as I have suggested, the meaning of his creative life and art lies with them. Despite his obsessive attention to women and his desire to exert power over them through hypnotism and other methods,[17] his views on proper representation of the female nude were conflicted. He objected to the pubic hair of Anders Zorns's nude bathers, describing them as "indecent, vulgar, obscene!"[18] Yet in his writings Eilshemius could be quite lascivious:

Oh! Show me the girl

With lash of jet,

With the raven black curl—

My true love's pet—

I'll feel like a god—like Jove I will feel

When Juno unloosed her zone for his weal![19]

Louis Eilshemius needs to be understood as a product of mid-nineteenth century morals and social conventions. The ubiquitous nudes encountered in his art provide insight into Victorian attitudes toward women and sex. The artist sought both avidly, but then seemed to run away from actual experience. This was the great unresolved issue of his life, a modern era focus that in his case was not just exaggerated but also fully displayed in works of art.

Eilshemius may have turned to the occult for remedy of an intolerable sexual frustration and romantic disappointment. Demon women, mysticism, and sex come together in some of his most intriguing paintings, all of them related to nineteenth-century symbolism and influential twentieth-century Freudian theories. What were Eilshemius's ideas in relationship to sexual desires and needs? How did these views square with prevalent contemporaneous notions of romantic love? The studies of feminist historians and ideas about the "male gaze" and sexuality in art provide a rich area in which to reconsider this artist.[20] Having asked these questions almost twenty-five years ago, I now find them even more relevant to the story of Eilshemius—and to an estimation of the significance of his career within an expanded view of the great early twentieth-century modernist adventure. For all their bizarre and even off-putting qualities (perhaps because of them), Eilshemius paintings continue to provide tantalizing glimpses of the back roads of modernism and the unfamiliar landscape one encounters when traveling them.

Finally, I would suggest that the art of Louis Eilshemius could usefully be looked at as a love affair with the world, with nature, landscape, New York City, and—above all—with women. His personal tragedy was due to love unreciprocated. Longing and desire increased as he became more socially isolated and professionally ignored, rebuffed by women and further marginalized by the art world. The sadness of this story is that the very needs that brought into the world the most poetic and original of Eilshemius's paintings finally overwhelmed him, causing him to abandon art and preventing him from enjoying the long-sought attention he finally received from many of his most advanced peers and colleagues.

For Eilshemius it was too late. The damage had been done. The artistic voice was silenced, to be replaced by complaining letters to the local press and grandiose claims of unacknowledged creative superiority. Eilshemius spent his final twenty years a famous but broken man, visited by the admiring and simply curious, having retreated entirely into the fantasy realm of his imagination. Arshile Gorky and Willem de Kooning were apparently among his younger visitors during the final years. It is a shame for him, and possibly our loss, that he no longer was able to give visual form with paint on canvas or cigar box lid to that troubled, uniquely fascinating and revealing world of Louis Michel Eilshemius. With benefit of this retrospective look, I find myself as convinced of that now as I was twenty-five years ago.

Paul J. Karlstrom
San Francisco, June 2001

1 My earlier work on Eilshemius was done in the early to mid-1970s, starting with my doctoral dissertation "Louis Michel Eilshemius, 1864–1941: A Monograph and Catalogue of the Paintings" (2 vols., University of California, Los Angeles, 1973) and an exhibition catalogue, The Romanticism of Eilshemius, for the Bernard Danenberg Gallery in New York (also 1973). There followed Louis Michel Eilshemius (New York: Harry N. Abrams, 1978) and Louis M. Eilshemius: Selections from the Hirshhorn Museum and Sculpture Garden (Washington, D.C.: Smithsonian Institution Press, 1978). Circulated by Smithsonian Institution Traveling Exhibition Services (SITES), the show went from Washington to the Herbert F. Johnson Museum of Art, Cornell University, Ithaca, New York; Fredrick S. Wight Gallery, UCLA; Joslyn Art Museum, Omaha; Springfield Museum of Fine Art, in Massachusetts; and several other venues. That same year two more articles appeared: "Eilshemius' pursuit of fame: a tragic story" in Smithsonian, 9, no. 8 (November 1978), pp. 98–104; and "Louis Michel Eilshemius: A Closer Look" in American Art and Antiques, 1, no. 2 (September/October 1978), pp. 60–69. This retrospective critical reflection also draws in part on my essay "Modernism through a Wide Angle Lens" in American Moderns, 1900–1950 (exhibition catalogue, Musée d'Art Américain Giverny, 2000).

2 Our view of twentieth-century American art had, in the 1960s, largely been determined by the ascendancy of abstract expressionism and the concurrent rise of criticism as a separate intellectual discipline. Clement Greenberg's influential role in establishing the formalist model (nonreferential abstraction) as both the objective and the measure of modernist art has been widely discussed. See, for example, Hal Foster's essay "Re: Post," in Art After Modernism:

Rethinking Representation, Brian Wallis ed., (New York: New Museum of Contemporary Art, 1984), pp. 189–91.

3 William Schack's *And He Sat Among the Ashes* (New York: American Artists' Group, 1939) was the first and, with the advantage of first-hand access to its subject, still remains the basic source for Eilshemius's life. An extremely sympathetic biographical account, the book is more psychological than art historical in its approach, novelistic in the manner of Irving Stone's widely read lives of Michelangelo and Vincent van Gogh.

4 Judging from a random review of recent surveys, the fate of Eilshemius seems to be that of a tenacious footnote. He appears, then is overlooked, only to reappear again. John I. H. Baur's *New Art in America* (Greenwich, Conn.: New York Graphic Society, 1957) reproduces five paintings (two of which are in the present exhibition) and Lloyd Goodrich's biographical entry states: "With the arrival of modernism Eilshemius finally received his due" (Goodrich, p. 36). He is omitted from Daniel M. Mendelowitz's *A History of American Art* (2nd ed. New York: Holt, Rinehart and Winston, 1970). Irma Jaffe's chapter "The Forming of the Avant-Garde 1900–30," in John Wilmerding ed., *The Genius of American Painting* (New York: Morrow, 1973), reproduces *Afternoon Wind* and describes Eilshemius as "one of the strangest eccentrics in American history" and his paintings as "wish-fulfillments and reenacted nightmares" (p. 246). He makes no appearance in *American Painting* by Jules David Prown and Barbara Rose (Geneva: Skira, 1969). But Wanda Corn, in *The Great American Thing: Modern Art and National Identity, 1915–1935* (Berkeley and Los Angeles: University of California Press, 1999), mentions Eilshemius twice. However, in both instances his name is invoked in connection with Duchampian "humor" and modernist endorsement of "'bad' taste." According to Corn, Eilshemius's "nudes were so crude as to be elevated in their [Duchamp's and Henri-Pierre Roché's] estimation" (p. 85) The implication is that Eilshemius, and the modernists' expressed enthusiasm for his work, is not to be taken seriously but rather understood in terms of an aesthetic bad joke.

5 Alfred Stieglitz apparently encouraged Georgia O'Keeffe to visit his "old friend" Eilshemius. When I asked her in a letter what was the basis for Stieglitz's interest (demonstrated in a kind correspondence as well as personal visits), O'Keeffe responded rather curtly "Eilshemius was Duchamp's best joke on the art world" (letter to the author, November 29, 1977). This corresponds to familiar views, as expressed above (note 4), held by many traditional art historians and museum curators. The unspoken comment is "how *could* someone as sophisticated as Duchamp take Eilshemius seriously as an artist."

6 Ed Ruscha, facsimile transmission to the author, June 7, 2001. Catalogue essayist Steven Harvey, himself an exhibiting painter, mentions fellow artists Paul Resika and Peter Schuyff (also a friend of Ruscha's) as admirers of Eilshemius. Furthermore, Eilshemius is reportedly one of the favorites of Leland Bell, according to John Ashbery in his February 1970 *Art News* review of Bell, reprinted in Ashbery's collection, *Reported Sightings: Art Chronicles, 1957–1987* (New York: Knopf, 1989), p. 196

7 According to a recent biography, Balthus visited the writer Henri-Pierre Roché in 1930 (Scarlett and Phillipe Reliquet, *Henri-Pierre Roché: l'enchanteur collectionneur*, Paris, Éditions Ramsay, 1999, p. 102). On the possible influence of *The Prodigy* on Balthus, see Harvey's essay, p. 27.

8 Milton Brown pointedly observed that Duchamp was closer to the French origins of modernism and was less concerned with style and execution than with the direct expression of individuality through an authentic voice. See *American Painting from the Armory Show to the Depression* (Princeton, N.J.: Princeton University Press, 1955), p. 111.

9 A transcript of "An Informal Talk/By Mr. Louis Eilshemius/Given at the Museum of Modern Art, Société Anonyme Inc./19 E. 47th Street, October 15, 1920" is reprinted here, p. 45. This document, somehow overlooked in my previous research, was brought to my attention by Steven Harvey. However, reading it critically, as one must do with all Eilshemius's pronouncements,

there is actually little there to alter the view of him as an artist with anti-modernist sentiments, his art determined less by theory or technical method than the irresistible force of inner needs associated with emotional life.

10 Ibid.

11 Mina Loy, "Pas de Commentaires! Louis Eilshemius," *The Blind Man*, no. 2 (May, 1917).

12 Roberta Smith, "Where Insanity and Modernism Intersect," *The New York Times*, April 21, 2000, section B, p. 33.

13 Eilshemius reportedly advised Robert Brackman to "paint his women with full bosoms and . . . in such manner that men would ask for the telephone numbers of the models, as often happened in the case of his own paintings." In James R. Mellow, "The Case of Eilshemius," *Arts*, 33 (April 1959), p. 40.

14 Catherine McNickle Chastain's "The Eilshemius Pendulum: Louis Eilshemius, Marcel Duchamp and the New York Art World" (Ph.D. diss. Emory University, Atlanta, 1998) provides an intriguing look at Eilshemius and his artistic practice. Especially revealing are his elaborate schemes—including hypnosis—to achieve power over women. Serving as an outside member of her doctoral committee, I had the opportunity to reengage Eilshemius on the updated terms (feminist and new-historicist) that inform this essay.

15 According to Eilshemius's account, "I went there [Apia, Samoa] for certain purposes, one of them to have models running around in the open. I was tired of drawing and painting them within a 20 x 15 feet large room. Well, Apia was an open heaven for me. [But] The girls are diffident and it required a lot of coaxing to have them pose in the altogether. Once the Chief's daughter came—but she would not pose utterly undressed." Three-page handwritten manuscript on letterhead, undated, entitled "Experiences of Eilshemius, M.A., No. 3." Provided to the author by Sterling Strausser, from his collection of Eilshemius paintings and memorabilia.

16 See my UCLA dissertation, vol. 2, "Catalogue of the Paintings." This estimate of over one thousand nudes is based on my partial catalogue that represents approximately one-third of the extremely prolific artist's total output, undoubtedly a conservative figure. Schack puts the count at more than 5,000 paintings. Of the works (including watercolors) in my catalogue, about 350 are female nude subjects.

17 Catherine Chastain is currently seeking a publisher for her book, *The Eilshemius Pendulum*, which traces the history of mesmerism and hypnosis in the United States as it applies to Eilshemius. Her work on the artist exemplifies the variety of productive directions Eilshemius studies can take beyond traditional art history.

18 Quoted by William Schack in *And He Sat Among the Ashes*, p. 4.

19 Fragment from "Ditty," published in *The Art Reformer*, 2 (October 1911), p. 7.

20 Particularly relevant in this regard is historian Sharon R. Ullman's study of the representation of sex in the early twentieth century and the role of early movies, vaudeville, and popular magazines and newspapers in issues of sexuality and gender in American society. Her account of the growing acknowledgement of female sexual desire and behavior, and the confusion and social anxiety surrounding these important (and threatening) changes, is informative in connection with Eilshemius's difficulties in adapting. See Ullman, *Sex Seen: The Emergence of Modern Sexuality in America* (Berkeley and Los Angeles: University of California Press, 1997).

Fig. 23 Eilshemius at 37, photographer unknown

An Informal Talk

BY MR. LOUIS EILSHEMIUS
GIVEN AT THE MUSEUM OF MODERN ART, SOCIETE ANONYME INC.
19 E. 47TH STREET, OCTOBER 15, 1920.

✳ ✳ ✳ ✳ ✳ ✳

Art is divided into 3 groups—
 1—Absolute Realism
 2—Pure Idealism
 3—The combination of these two
 (half Realism/half Idealism)

Most of the paintings we see are purely realistic, especially as shown in the academic salons. They generally wish to just copy what they see. In other words, they paint objects as they are.

In idealism we have other side of the question, namely where we want to express something beyond realism. The realistic part is there, but we imbue the realistic part with imagination and mystery; for instance some good examples of the idealistic part are-

Blake[1]—he is realistic, but he imbues the subject with poetry and mystic imaginative ideas, which is more difficult to produce than to copy a little girl sitting on a veranda and scenting a blossom, or playing with a little dolly. That is pure realism-there is no mystery, imagination and little poetry in that.

Theodore Watts,[2] the English artist—he put poetry and soul—imagination into his paintings. For instance there is Youth and Death—an angel leading a young girl up from the earth to the skies. That is called imaginative painting—you have to think before you understand the subject, exercise your own imagination and see something which you do not see every day. That is higher art than pure realism.

The academic artists just paint what they see. Why imitate the academic all the time? It grows monotonous after a while to see the same pictures all the time. In other words it is better to put yourself [text missing from original typescript] -ings with individuality—that is higher art than to just copy what you see. In music Beethoven could not have existed if he had copied other composers. When he started, he copied Haydn—his first sonatas were just imitations of Haydn. He said he will be himself, Beethoven. After that he composed real sonatas, and later on he composed symphonies, which are not imitative. Then we had a Beethoven.

Take my pictures. There you find action-clear action which is not perceptible at once, but little by little grows upon you. If you look at one of my paintings—like that—for five minutes,—it will move.

You ask "How do you get action?"

Eliminate all the details which are not necessary. The academic painters put in every little detail. It is impossible for the figure to move. The academic painter gets close to the figure and puts in every little detail. That prevents motion—or if he paints motion he gets arrested action. You cannot in life see every detail when there is motion.

The way to get action is to observe in the street, any place where you are observing people in motion, while they are moving around. Observe how they move until all the motions are in your memory, and you see them there without having any object before you. Then you can take your brush and colors and know exactly what to leave out. When the head is moved, all of a sudden I see detail which is elastic and by not putting that into the painting I get motion. You cannot get motion if you put every little detail of the body. Painting the whole figure as I see it, I get the character of the face, the softness of the line. I leave out the indications of little muscles—just get the effect, then you get life. That is the difference between academic painting and modern art.

Some artists use the camera for action. One great man who had the habit of using the camera was Remington.[3] The camera gives you arrested motion, angular, not moving on—you have to get that by feeling it by yourself, not by the camera. Self-drawn action allows the figure to move forward.

Formerly, I used to paint in the academic style, and ten years ago I changed my style because I wanted to express ideals, then I wanted to express effects—unusual effects we see in nature, like hill sides and storms throwing down rocks. I wanted to express a symphony of lines. . . .All the lines must convolute into each other, winde [sic] about each other, until every line goes to the center of the painting. That produces a point of focus where you have to see the

most interesting part of the picture which I wish to express. And by using this means the eye has to go to the central part of the picture.

The next thing to observe is that the detail—is less visible away from the principal interest. The academicians are apt to put the detail the same all over.

Each subject in the painting should have a special technique. The academicians generally want the same technique for everything, and that is wrong. Each object ought to have a special technique. An artist in the Academy of Design paints his trees as he does his figures. Trees ought to have a special technique to make them look like trees, but he paints his trees the same as he paints a Turkish rug, as he paints his figures—just puts on dabs of paint. You have to imagine it is a figure. He paints his sky like rocks and his rocks like sky. The same technique—dabs of paint.

The most celebrated academician in New York paints in the smooth style and he does not know how to paint a rock. He paints his rock just as smooth as he paints a nude. It looks like papier mache, or like stage scenery. Because that poor academician never studies rocks. He only studies figures. An artist should study everything. Every object necessitates a different technique, different brush work, different way of handling the paint. A painter to be a true artist should rise higher than the commercial, the realistic. There is too much of this every day art in the city. Walk down Fifth Avenue, you never see any real art in the galleries. There are just a few landscapes, figures, dressed up dolls, fashionplate figures.

Does not the public grow tired of the sameness of the Academy. The exhibition of the Academy of Design where every painting is the same as last year. You would think the painters had not sold the pictures and had sent the same to each new exhibition.

The real object of art is to represent on canvas the soul of things, of persons and of landscape. The other thing is just painting. Real art is painting, plus the introduction of soul quality, which you have not in the realistic painting. All other art is not of the soul. Whitman,[4] Robert Browning[5]—the only thing worth while in poetry is the soul quality of the author; otherwise it is prose. The same thing in music—Mozart—each composition expressed his soul, not just notes, but divine melodies Mozart expressed the soul of the mortal. Lansier[6] [sic] painted the picture of the dog at the feet of his dead master. It was not truly academic. You see the soul of the dog gazing at his dead master, so well expressed in the dog's eye. You feel that the dog is pitying the fate of his master. To express that is real art. To do that you must be a soulful man yourself, otherwise you cannot express it.

Greater than Massonier's [sic] "Freedman"[7] is Manet's "Christ." He put soul into the face of Christ and the bended figure of the Madonna. Modern art is seeking to express the soul. Most so-called Masters did not do that. They expressed surfaceness, not the soul. A great academician who painted Andromacha had no soul, because he himself was not a soulful man. Therefore how could he express the soul in his painting.

An artist must not produce what other people want him to produce. Real art is to produce what he himself wants to produce, then he will produce art. Other artists may not appreciate it at once but will appreciate it later on.

Soul work is a conception, a vision. Blake saw all the pictures he painted in his mind before he painted them. The realists must always have something before them.

The soulful man feels, meditates and walks around the room. He does not take a pencil and make a design. He takes brushes and paints and paints the whole thing right on the canvas, and before he knows it, it is there. Once you get the vision, it is there. The realist has to have the model before him.

Everybody can produce academic art, but everybody cannot produce soul art.

One must school oneself to memorize everything one sees on his way, that is why one's mind is all filled with memories and souvenirs of what one has seen. When painting, one recalls these things and can produce them on canvas. Chinese boys were taught to pass a store window quickly and when they got home they had to note down everything they had seen. That is a good plan for training the eye and memory.

This text is from the Katherine Dreier Collection in the Beinecke Rare Book and Manuscript Library, Yale University Library, used with permission.

1 William Blake (1757–1827), English poet, painter and engraver.
2 Eilshemius is probably referring to George Frederic Watts (1817–1904), an English Pre-Raphaelite/Symbolist painter and sculptor.
3 Frederic Remington (1861–1909), American painter and sculptor.
4 Walt Whitman (1819–1892), American poet.
5 Robert Browning (1812–1889), English poet.
6 Sir Edwin Henry Landseer (1802–1873), English painter. The painting Eilshemius describes is *The Faithful Hound*, c. 1830.
7 Eilshemius is referring to *Friedland*, painted by Ernest Meissonier (French painter, 1815–1891). Today the painting still hangs in The Metropolitan Museum around the corner from *The Dead Christ and the Angels*, by Edouard Manet (French painter, 1832–1883), to which Eilshemius also refers.

Chronology

1864

Born February 4, at Laurel Hill Manor in North Arlington, New Jersey, Louis Michel Eilshemius is the sixth child of wealthy and socially prominent parents. His father, Henry Gustave Eilshemius (1818–1892), born in Germany of Dutch descent was for many years a successful importer. His mother, Cecilie Elise (Robert) Eilshemius (1827–1911), also an immigrant, of French-Swiss descent, was a cousin of the Swiss painter Leopold Robert.

1873

Attends school in Geneva, Switzerland, with older brother Victor. Victor's death the following year deeply affects Eilshemius.

1881

In Dresden, Germany, attends *Realschule*, where he receives first elementary art training in an otherwise commercial curriculum.

1881

Works for nine months as a bookkeeper in a New York wholesale glove house to appease his father who wants him to take up business.

1883

Studies agriculture at Cornell University, Ithaca, New York, from January 5, 1882 to December 21, 1883.

1886

Enrolls at the Art Students League in New York. Dissatisfied with the instruction he studies privately with Robert C. Minor, an American follower of French Barbizon painters, whose influence is reflected in Eilshemius's early landscapes.

1886

Travels to Paris to study at the Académie Julian. Shares studio with fellow American student Robert W. Chambers, on the rue de Vaugirard, opposite the Palais du Luxembourg.

1887

The National Academy of Design, New York, accepts his landscape *Evening, Milford, Pa.*, for its Sixth Autumn Exhibition.

Fig. 24 Eilshemius's home at 118 East Fifty-seventh Street

1888

Moves into brownstone at 118 East Fifty-seventh Street, New York, acquired by his parents, where he would live for the rest of his life. Two landscapes, *Silver Cascade, Delaware Water Gap, Pa.*, and *Delaware Water Gap Village, Pa.*, are included in the Seventh Autumn Exhibition of the National Academy of Design and shown again, the first in 1890, the second in 1891, in the annual exhibitions of the Pennsylvania Academy of the Fine Arts. Eilshemius will submit many more works to official exhibitions, but these are the last that are accepted.

1889

Summer trip to California with older brother Frederick.

1890

Begins to sign his work "Elshemus"—a practice he continues until 1913. He apparently believes the difficult spelling of his name impedes acceptance of his paintings.

Fig. 25 Eilshemius's home at 118 East Fifty-seventh Street

1892

His father dies. Eilshemius's share of the estate allows him to travel.

1892–93

Travels to Europe and North Africa.

1893–94

Travels to California with apparent intention of settling there. Establishes a studio in Los Angeles where he spends the winter and begins a number of paintings. En route home, visits Yuma, Arizona (March 1894).

1895

Begins regular publishing activities with publication of two volumes of poetry.

1896

His brother Frederick dies.

1897

First one-man show in the shop of his framemaker, Philip Suval, New York.

1898

Joins Salmagundi Club in an effort to make professional contacts and exhibit his work.

1900

Visits in the fall with decorator and landscape painter Lyell Carr and his wife in Old Lyme, Connecticut. Among his few artist-friends, Carr is apparently the only one who ever accompanies him on a sketching expedition.

1901

In August sails from San Francisco to Honolulu and the South Pacific. Arrives in September at Apia, Samoa. This locale later provides inspiration for one of his greatest series of paintings, based on photographs, drawings and watercolors from this voyage. The trip carries Eilshemius as far as Auckland, New Zealand.

1902

Travels through the southern states, with visits in Tennessee, Louisiana, and Florida.

1903

Sails to Europe with the intention of settling in Rome. Working with groups of female models in his large studio there, he produces his most ambitious nude figure paintings, such as *Dancing in the Sunlight* (cat. no. 10).

1904

Continues his publishing activities and resigns from the Salmagundi Club.

1906–7

Period of great productivity and achievement culminates in the Samoan paintings. Highpoint of his personally financed publishing activity is the appearance, in 1907, of six volumes, including the 508-page *Fragments and Flashes of Thought*. Travels again to Europe.

1908

After visiting Albert Pinkham Ryder's studio in New York, Eilshmius paints his own version of *Macbeth and the Witches* (Worcester Art Museum) and *The Flying Dutchman* (Whitney Museum of American Art). Becomes acquainted with painter Abraham Walkowitz who recently returned from Paris.

1909

Begins using title "M.A." after his name. Produces first issue of his periodical, *The Art Reformer*. Begins printing and distributing self-praising handbills.

1910

Production of paintings decreases sharply. Drawing and watercolors are set aside. Trying to economize, he abandons canvas for shirtboards, sheet music, and cigar-box lids.

1911

His mother dies. Eilshemius is now dependent upon his older brother Henry, with whom he lives. Begins practice of visiting galleries and vociferously criticizing exhibited work, a habit for which he becomes notorious among New York dealers. Incidents of eccentric behavior increase along with the number of letters he writes to newspapers (particularly the *New York Sun*) and to art periodicals. This correspondence will peak about 1918, but continues well into the 1930s. Eilshemius is befriended by Babcock Galleries director Carmine Dalesio, New York.

1912
Stops painting for about a year.

1913
Painting again, he resumes the proper spelling of his name. Armory Show exhibition committee rejects several pictures.

1914–8
Holds a series of unsuccessful studio exhibitions, which includes paintings of World War I.

1917
Two recent paintings, *Rose-Marie Calling (Supplication)* and *The Gossips*, are included in the Society of Independent Artists First Annual Exhibition, where Eilshemius is discovered by Marcel Duchamp. He is joined in his praise by Gaston Lachaise, Joseph Stella, Abraham Walkowitz, and other artists and intellectuals.

1920
First one-man show at the Société Anonyme, New York, sponsored by Katherine S. Dreier and Duchamp. Show includes mostly recent paintings, which were received negatively by many critics.

1921
Stops painting.

1924
Friends and admirers continue to support Eilshemius. Second one-man show at the Société Anonyme, featuring Samoan paintings, persuades *New York Sun* critic Henry McBride to become Eilshemius's champion in the press. Eilshemius is listed as a member of the Society of Independent Artists, New York.

1925
Babcock Galleries takes some paintings on consignment.

1926
Valentine Dudensing becomes Eilshemius's dealer; mounts one-man show. Negative response discourages Dudensing from holding another for six years.

1931
Eilshemius assumes title of "Mahatma" as a result of correspondence with book dealer in India who arranges exhibition of watercolors and oils.

1932
Two exhibitions at Valentine Gallery, New York, span Eilshemius's career. Summer exhibition at Galeries Durand-Ruel, Paris, received enthusiastically; *The Gossips* is acquired by Musée du Jeu de Paume, Paris. Eilshemius is hit by an automobile in New York and incapacitated. Hereafter, he is confined to a bedroom at 118 East Fifty-seventh Street. More than twenty-five one-man shows in New York between 1932 and 1941; numerous reviews and articles.

1939
Three simultaneous one-man shows in New York. William Schack's biography of Eilshemius, *And He Sat Among the Ashes*, is published.

1940
Death of brother Henry leaves Eilshemius in a state of helpless poverty. Family home is heavily mortgaged, taxes overdue. Schack and members of American Artists Group raise some funds to provide assistance.

1941
Eilshemius is taken to Bellevue Hospital, New York, where he dies of pneumonia, on December 29. Funeral and burial at Greenwood Cemetery, Brooklyn, is attended by leading New York artists, critics, and museum curators.

Adapted from Paul Karlstrom, *Louis Michel Eilshemius*, Harry N. Abrams, Inc., New York, 1978

1. *Delaware Water Gap Village*, ca. 1886
Signed lower right: Eilshemius
Oil on canvas
25 x 29⅞ inches

The Metropolitan Museum of Art, New York, Arthur Hoppock Hearn Fund, 1950. 50.125

PROVENANCE
The artist's family; Maurice Fried.

EXHIBITIONS
New York, Columbia University, December 1955; New York, The Artists' Gallery, *Masterpieces of Eilshemius*, April 1959, no. 1; Washington, D.C., Phillips Gallery, *Masterpieces of Eilshemius*, May 10–June 1, 1959; Washington, D.C., Corcoran Gallery of Art, July–August 1975; Binghamton, New York, January 21–February 13, 1983; Trenton, New Jersey, New Jersey State Museum, *19th Century Painters of the Delaware Valley*, March 12–April 24, 1983.

LITERATURE
Masterpieces of Eilshemius, New York, The Artists' Gallery, 1959, pl. 1; Paul J. Karlstrom, *Louis Michel Eilshemius*, New York, Harry N. Abrams, Inc., 1978, pp. 44, 56 & 104; Doreen Bolger Burke, *American Paintings in the Metropolitan Museum of Art, Vol. III. A Catalogue of Works by Artists Born Between 1846 and 1864* , New York, The Metropolitan Museum of Art, 1980, pp. 456–457.

2 *Mother Bereft*, ca. 1890
Signed lower right: Elshemus
Oil on canvas
20½ x 14½ inches

Hirshhorn Museum and Sculpture Garden, Smithsonian Institution, Washington, D.C. Gift of the Joseph H. Hirshhorn Foundation, 1966

PROVENANCE
Kleemannn Galleries, New York; Joseph H. Hirshhorn

EXHIBITIONS
New York, Kleemann Galleries, *All of Eilshemius*, October 1937, no. 4; New York, Kleemann Galleries, *Louis M. Eilshemius*, February 1950, no. 10; New York, The Artists' Gallery, *Masterpieces of Eilshemius*, April 1959, no. 2; American Federation of Arts, *Paintings from the Joseph H. Hirshhorn Foundation Collection: A View of the Protean Century*, traveling exhibition, November 1962–March 1965, no. 24; Washington, D.C., Hirshhorn Museum and Sculpture Garden, Smithsonian Institution, *Inaugural Exhibition*, October 1974–September 1975, no. 116; Washington, D.C., Hirshhorn Museum and Sculpture Garden, Smithsonian Institution, *Louis M. Eilshemius: Selections from the Hirshhorn Museum and Sculpture Garden*, November 9, 1978–January 1, 1979, no. 12 (traveling exhibition 1979–80); Evanston, Illinois, Terra

Museum of American Art, *Treasures from the Hirshhorn: American Painting, 1880–1930*, July 29–September 8, no. 9.

LITERATURE
Howard Devree, "All of Eilshemius," *Magazine of Art*, October 1937, p. 610, ill. p. 606; "Dramaticism, Lyricism and Eilshemius," *Art Digest*, October, 1, 1937, p. 9; William Schack, *And He Sat Among the Ashes*, New York, American Artists' Group, 1939, p. 66; Forbes Watson, *American Painting Today*, Washington, D.C., American Federation of Arts, 1939, ill. p. 63; *Masterpieces of Eilshemius*, New York, The Artists' Gallery, 1959, pl. 2; Robert M. Coates, "Eilshemius and Duchamp," *New Yorker*, April 18, 1959, p. 151; Manny Farber, "Eilshemius: Artist behind Mahatma," *Art News*, April, 1959, p. 5 and cover illus.; Abram Lerner, ed., *The Hirshhorn Museum and Sculpture Garden, Smithsonian Museum*, New York, Harry N. Abrams, 1974, p. 689; Paul J. Karlstrom, *Louis Michel Eilshemius*, New York, Harry N. Abrams, Inc., 1978, p. 48, col. pl. 101; Paul J. Karlstrom, *Louis M. Eilshemius: Selections from the Hirshhorn Museum and Sculpture Garden*, Washington, D.C., Smithsonian Institution Press, 1978, no. 12, p. 68; Donald Goddard, *American Painting*, New York, Hugh Lauter Levin Associates, 1990.

3. *Edge of Woods*, 1891
Signed and dated lower right: Elshemus 1891
Oil on cardboard
12 x 10 inches

Roy R. Neuberger Collection

PROVENANCE
Valentine Dudensing, New York.

EXHIBITIONS
American Federation of Arts traveling exhibition, *Paintings by Eilshemius from the Collection of Mr. and Mrs. Roy R. Neuberger*, October 1961–October 1962, no. 1; Columbus, Ohio, Columbus Gallery of Fine Arts, *The Neuberger Collection*, January 9–February 23, 1964, no. 1.

LITERATURE
Daniel Robbins, *An American Collection*, Providence, Rhode Island Museum of Art, Rhode Island School of Design, 1968, p. 135 (illus. p. 149).

4. *Mirage in Africa*, ca. 1892
Signed lower right: Elshemus
Oil on canvas
12 x 16 inches

Robert K. Fitzgerel Collection

PROVENANCE
Kleemann Galleries, New York; Rembrandt Art Gallery, New York.

5. *Village Near Delaware Water Gap*, ca. 1896
Signed lower right: Elshemus
Oil on canvas
20 x 30 inches

Addison Gallery of American Art, Phillips Academy, Andover, Massachusetts. Museum purchase, 1933.25

PROVENANCE
Valentine Gallery, New York; William MacBeth Gallery, Inc., New York.

EXHIBITIONS
New York, Valentine Gallery, October 1933, as "Lake, Delaware Water Gap"; North Andover, Mass., Stevens Memorial Library, 1952; American Federation of Arts traveling exhibition, *American Painting 1800-1900*, August 1954–July 1955; Bradford, Mass., Laura Knott Gallery, Bradford College, 1970; New York, Bernard Danenberg Galleries, *The Romanticism of Eilshemius*, 1973, no. 1; Washington, D.C., Corcoran Gallery of Art, 1975.

LITERATURE
Milton Mackey, "Profiles, The Mahatma," *NY Magazine*, September 14, 1935; *Handbook of the Addison Gallery of America Art*, Phillips Academy, Andover, Massachusetts, 1939, p. 56 (illus.); Paul J. Karlstrom, *Louis Michel Eilshemius*, New York, Harry N. Abrams, Inc., 1978, pl. 108; *The Romanticism of Eilshemius*, New York, Bernard Danenberg Galleries, 1973, p. 2. (illus.).

6. *Night View of Manhattan*, 1897
Signed and dated lower right: Eilshemius 97
Oil on cardboard
12¾ x 18⅞ inches

Herbert Lust Gallery, New York City

PROVENANCE
Douglas Rigby, Sodona, Arizona.

LITERATURE
Paul J. Karlstrom, *Louis Michel Eilshemius*, New York, Harry N. Abrams, Inc., 1978, p. 61, pl. 112.

7. *Afternoon Wind*, 1899
Signed and dated lower right: Eilshemius 1899
Oil on canvas
20 x 36 inches

The Museum of Modern Art, New York. Given anonymously, 1941

PROVENANCE
Kleemann Galleries, New York; Steven C. Clark.

EXHIBITIONS
New York, The Artists' Gallery, *Masterpieces of Eilshemius*, April 1959, no. 6; New York, The Museum of Modern Art, *Romantic Painting in America*, 1943–1944; New York, Bernard Danenberg Galleries, *The Romanticism of Eilshemius*, 1973, no. 23.

LITERATURE
Lloyd Goodrich, *New Art in America*, Greenwich, CT, New York Graphic Society, p. 35, 1957 (color illus.); *Arts*, April 1959, p. 40 (illus. p. 38); *Museum of Modern Art Bulletin*, April–May, 1941; *Time*, March 15, 1963, p. 84 (illus); Paul J. Karlstrom, *Louis Michel Eilshemius*, New York, Harry N. Abrams, Inc., 1978, p. 84, pl. 115; *The Romanticism of Eilshemius*, New York, Bernard Danenberg Galleries, 1973, p. 20; *Masterpieces of Eilshemius*, New York, The Artists' Gallery, 1959, pl. 6.

8. *American Tragedy: Revenge*, ca. 1901
Signed lower left: Elshemus
Oil on canvas
20⅛ x 30⅛ inches

Hirshhorn Museum and Sculpture Garden, Smithsonian Institution. Gift of Joseph H. Hirshhorn, 1966

PROVENANCE
Kleemann Galleries, New York; Joseph H. Hirshhorn.

EXHIBITIONS
New York, Kleemann Galleries, *All of Eilshemius*, October 1937, no. 11; Washington, D.C., Hirshhorn Museum and Sculpture Garden, Smithsonian Institution, *Louis M. Eilshemius: Selections from the Hirshhorn Museum and Sculpture Garden*, November 9, 1978–January 1, 1979, no. 11 (toured US 1979–80).

LITERATURE
Paul J. Karlstrom, *Louis Michel Eilshemius*, New York, Harry N. Abrams, Inc., 1978, pl. 121; Paul J. Karlstrom, *Louis M. Eilshemius: Selections from the Hirshhorn Museum and Sculpture Garden*, Washington D.C., Smithsonian Institution Press, 1978, p. 47; Paul Richard, "Beckoning Bridges," *Washington Post*, March 15, 1987, F5; William Schack, *And He Sat Among the Ashes*, New York, American Artists' Group, 1939, p. 71.

9. *The Demon of The Rocks*, 1901*
Signed and dated lower left: Elshemus 1901
Oil on cardboard
20 x 15⅛ inches

The Museum of Modern Art, New York. Gift of Fania Marinoff van Vechten in memory of Carl van Vechten. 285.65

PROVENANCE
Fania Marinoff van Vechten.

EXHIBITIONS
New York, Bernard Danenberg Galleries, *The Romanticism of Eilshemius*, 1973, no. 31; Trenton, New Jersey, New Jersey State Museum, *Louis Eilshemius*, December 2, 1978–January 7, 1979; New York, New York University, Grey Art Gallery, *American Painting and Symbolist Aesthetics 1885–1917*, October 24–December 8, 1979.

LITERATURE
The Romanticism of Eilshemius, New York, Bernard Danenberg Galleries, 1973, p.14 (illus.); Paul J. Karlstrom, *Louis Michel Eilshemius*, New York, Harry N. Abrams, Inc., 1978, p. 73, pl. 154.

*Although the painting is dated 1901, the painted frame, subject matter and style suggest a date of c. 1910.

10. *Dancing in the Sunlight*, 1903

Signed and dated lower right: Elshemus. copyright 1903
Oil on canvas
24¼ x 37⅛ inches

Hirshhorn Museum and Sculpture Garden, Smithsonian Institution. Gift of Joseph H. Hirshhorn, 1966

PROVENANCE
Kleemann Galleries, New York; Parke-Bernet Galleries, New York, February 20, 1963, lot 90, ill.; Joseph H. Hirshhorn.

EXHIBITIONS
New York, Kleemann Galleries, *All of Eilshemius*, October 1937, no. 24; New York, Museum of Modern Art, *Paintings for Paris*, November 8–December 13, 1937, no. 10; New York, Kleemann Galleries, *Painting by Louis M. Eilshemius*, June 1943, no. 9, as "Dancing in the Sun;" New York, Kleemann Galleries, February 1950, no. 2; Washington, D.C., Hirshhorn Museum and Sculpture Garden, Smithsonian Institution, *Louis M. Eilshemius: Selections from the Hirshhorn Museum and Sculpture Garden*, November 9, 1978–January 1, 1979, no. 20 (toured US 1979–80).

LITERATURE
Amy Robinson, "Reviews and Previews: Eilshemius," *Art News*, February, 1950, pl. 10, p. 46; Howard Fox, "A Louis M. Eilshemius Portfolio," *Sun & Moon: A Quarterly of Literature and Art*, no. 2, Spring, 1976, illus. p. 54; Paul J. Karlstrom, *Louis Michel Eilshemius*, New York, Harry N. Abrams, Inc., 1978, pl. 53; Paul J. Karlstrom, *Louis M. Eilshemius: Selections from the Hirshhorn Museum and Sculpture Garden*, Washington D.C., Smithsonian Press, 1978, pp. 52-53, 95 (illus.).

11. *Figures in Landscape*, 1906

Signed and dated lower left: Elshemus 1906
Oil on canvas
22½ x 35¾ inches

Whitney Museum of American Art, New York. Gift of Louise Nevelson, 56.14

PROVENANCE
Louise Nevelson, New York.

EXHIBITIONS
New York, Chinese Gallery, October 1947; New York, Poindexter Gallery, October 1957; New York, The Artists' Gallery, *Masterpieces of Eilshemius*, April 1959, no. 8; New York, Whitney Museum of American Art, *American Art of the Twentieth Century, Selections from the Permanent Collection*, June 30–September 24, 1967.

LITERATURE
Paul J. Karlstrom, *Louis Michel Eilshemius*, New York, Harry N. Abrams, Inc., 1978, pl. 131; *Masterpieces of Eilshemius*, New York, The Artists' Gallery, 1959, pl. 8.

12. *Afternoon Rest*, 1907

Signed and dated lower right: Elshemus 1907
Oil on masonite
27 x 22¾ inches

Robert K. Fitzgerel Collection

PROVENANCE
Solomon Fleischman, New York; Reverend John Kelly, Stamford, Connecticut; Parke-Bernet Galleries, New York, May 26, 1949, lot 74; Alfredo Valente Gallery, New York; Maxwell Galleries, San Francisco; Bernard Danenberg Gallery, New York; Artists' Unlimited Gallery, New York.

EXHIBITIONS
New York, Bernard Danenberg Galleries, *The Romanticism of Eilshemius*, April,1973, no. 15; Rockland, Maine, Farnsworth Art Museum, 1985.

LITERATURE
The Romanticism of Eilshemius, New York, Bernard Danenberg Galleries, 1973, p. 9 (illus.); Paul J. Karlstrom, *Louis Michel Eilshemius*, New York, Harry N. Abrams, Inc., 1978, pl. 137.

13. *59th Street*, 1907

Signed lower right: Elshemus
Oil on masonite
15⅜ x 27½ inches

Robert K. Fitzgerel Collection

PROVENANCE
Valentine Gallery, New York; Artists' Unlimited Gallery, New York; Private Collection, Florida.

EXHIBITIONS
Kalamazoo, Missouri, Kalamazoo Institute of Art; Rockland, Maine, Farnsworth Art Museum, 1985.

14. *Samoa*, 1907

Signed and dated lower left: Elshemus 1907
Oil on panel
27½ x 23½ inches

Harry and Cookie Spiro

PROVENANCE
Valentine Gallery, New York; Mrs. John D. Rockefeller, Jr., New York.

LITERATURE
William Schack, *And He Sat Among the Ashes*, New York, American Artist's Group, 1939, p. 157.

15. *Samoa, Beach at Apia*, 1907

Signed and dated lower right: Elshemus 1907
Oil on board
23½ x 26¾ inches

Roy R. Neuberger Collection

PROVENANCE
Valentine Dudensing, New York.

EXHIBITIONS
New York, Bernard Danenberg Galleries, *The Romanticism of Eilshemius*, April 1973, no. 20.

LITERATURE
Daniel Robbins, *An American Collection*, Providence, Rhode Island Museum of Art, Rhode Island School of Design, 1968, p. 138 (illus. p. 192); *The Romanticism of Eilshemius*, New York, Bernard Danenberg Galleries, 1973, pl. 22; Paul J. Karlstrom, *Louis Michel Eilshemius*, New York, Harry N. Abrams, Inc., 1978, pl. 146.

16. *Samoan Nude Wading*, 1907

Signed and dated lower left: Elshemus 1907
Oil on board
14 x 10½ inches

Roy R. Neuberger Collection

PROVENANCE
Valentine Dudensing, New York.

EXHIBITIONS
American Federation of Arts traveling exhibition, *Paintings by Eilshemius from the Collection of Mr. and Mrs. Roy R. Neuberger*, October 1961–October 1962, no. 3; Columbus, Ohio, Columbus Gallery of Fine Arts, *The Neuberger Collection*, January 9–February 23, 1964, no. 2.

LITERATURE
Daniel Robbins, *An American Collection*, Providence, Rhode Island Museum of Art, Rhode Island School of Design, 1968, p. 138 (illus. p. 203); Paul J. Karlstrom, *Louis Michel Eilshemius*, New York, Harry N. Abrams, Inc., 1978, pl. 145.

17. *Samoan Venus*, 1907

Signed and dated lower right: Elshemus 1907
Oil on board
26½ x 23 inches

Roy R. Neuberger Collection

PROVENANCE
Valentine Dudensing, New York.

EXHIBITIONS
New York, Valentine Gallery, October 1933; Bethlehem, Pennsylvania, Lehigh University, *Oils- Watercolors by Louis M. Eilshemius from the Collections of Roy R. Neuberger and Sterling Strauser*, April 6–May 16, 1961, no. 8; American Federation of Arts traveling exhibition, *Paintings*

by Eilshemius from the Collection of Mr. and Mrs. Roy R. Neuberger, October 1961–October 1962, no. 2; Columbus, Ohio, Columbus Gallery of Fine Arts, *The Neuberger Collection*, January 9–February 23, 1964, no. 3.

LITERATURE
Paul J. Karlstrom, *Louis Michel Eilshemius*, New York, Harry N. Abrams, Inc., 1978, pl. 148; Daniel Robbins, *An American Collection*, Providence, Rhode Island Museum of Art, Rhode Island School of Design, 1968, p. 141 (illus. p. 189).

18. *The Dream*, 1908

Signed and dated lower left: Elshemus 1908
Oil on cardboard
27 x 38 inches

Collection Neuberger Museum of Art, Purchase College, State University of New York. Gift of Roy R. Neuberger

PROVENANCE
Valentine Dudensing, New York.

EXHIBITIONS
New York, Graham Gallery, *Eilshemius, 1864–1941*, January 4–28, 1961, no. 10; American Federation of Arts traveling exhibition, *Paintings by Eilshemius from the Collection of Mr. and Mrs. Roy R. Neuberger*, October 1961–October 1962, no. 5; Columbus, Ohio, Columbus Gallery of Fine Arts, *The Neuberger Collection*, January 9–February 23, 1964, no. 6.

LITERATURE
Daniel Robbins, *An American Collection*, Providence, Rhode Island Museum of Art, Rhode Island School of Design, 1968, p. 141 (illus. p. 175); Paul J. Karlstrom, *Louis Michel Eilshemius*, New York, Harry N. Abrams, Inc., 1978, pl. 148.

19. *East Side, New York*, ca. 1908

Signed lower left: Elshemus
Oil on paperboard
15 x 13⅝ inches

Hirshhorn Museum and Sculpture Garden, Smithsonian Institution, Gift of Joseph H. Hirshhorn, 1966

PROVENANCE
Stanley N. Barbee, Beverly Hills, California; Parke-Bernet Galleries, New York, March 23, 1961, lot 75, ill.; Joseph H. Hirshhorn.

EXHIBITIONS
New York, Balin-Traube Gallery, *Louis M. Eilshemius*, March 5–30, 1963; New York, The Jewish Museum, *The Lower East Side: Portal to American Life (1870–1924)*, September 21–November 6, 1966, no. 11 and Washington, D.C., Arts and Industries Building, Smithsonian Institution, December 17, 1967–January 18, 1968; Washington, D.C., Hirshhorn Museum and Sculpture Garden, Smithsonian Institution, *Inaugural Exhibition*, October 4, 1974–September 15, 1975, no. 218; Washington, D.C., Hirshhorn Museum and Sculpture Garden, *Louis*

M. Eilshemius: Selections from the Hirshhorn Museum and Sculpture Garden, November 9, 1978–January 1, 1979, no. 30 (traveling exhibition 1979–1980).

LITERATURE

Barbara Rose, "New York Letter," *Art International*, April 25, 1963, p. 60; Jay Jacobs, "Collector: Joseph H. Hirshhorn," *Art in America*, July–August 1969, pl. 61; Jean Lipman, ed., *The Collector in America*, New York, Viking Press, 1971, p. 86; Abram Lerner, ed., *The Hirshhorn Museum and Sculpture Garden, Smithsonian Institution*, New York, Harry N. Abrams, 1974, pp. 689–90, illus. p. 166; Howard Fox, "A Louis M. Eilshemius Portfolio," *Sun and Moon: A Quarterly of Literature and Art*, Spring 1976, illus. p. 53; Paul J. Karlstrom, *Louis Michel Eilshemius*, New York, Harry N. Abrams, 1978, pp. 63, 72, pl. 159; Paul J. Karlstrom, *Louis M. Eilshemius: Selections from the Hirshhorn Museum and Sculpture Garden*, Washington, D.C., Smithsonian Institution Press, 1978, pp. 23, 58 (illus.).

20. *The Flying Dutchman*, 1908

Signed and dated lower right: Elshemus 1908

Oil on composition board

23½ x 25½ inches

Whitney Museum of American Art, New York. Gift of Gertrude Vanderbilt Whitney, 31.189

PROVENANCE

Valentine Galley, New York.

EXHIBITIONS

New York, Valentine Gallery, 1926, no. 18; New York, Whitney Museum of American Art, *Opening Exhibition—Part I of the Permanent Collection: Painting and Sculpture*, November 18, 1931–January 2, 1932; New York, Whitney Museum of American Art, *Summer Exhibition: Paintings, Sculpture, Prints and Watercolors*, May 4–June 30, 1933; New York, Whitney Museum of American Art, *Fall Exhibition of Paintings, Prints, Sculpture from the Permanent Collection*, October 2–18, 1934; New York, Whitney Museum of American Art, *Selection of Works from the Permanent Collection*, September 15–October 9, 1938; New York, Whitney Museum of American Art, *One Hundred Important Paintings from the Museum's Permanent Collection*, April 1–May 29, 1942; New York, The Artists' Gallery, *Masterpieces of Eilshemius*, April 1959, no. 12; New York, Whitney Museum of American Art, *Seventy Years of American Art, Permanent Collection*, July 3–September 28, 1969; New York, Whitney Museum of American Art, *American Art: 1900–1949*, September 29–November 4, 1969; New York, Whitney Museum of American Art, *Selections from the Permanent Collection*, November 11–December 21, 1969; New York, Bernard Danenberg Galleries, *The Romanticism of Eilshemius*, April 1973, no. 35.

LITERATURE

William Schack, *And He Sat Among the Ashes*, New York, American Artists' Group, 1939, p. 151 (illus. p. 177); Paul J. Karlstrom, *Louis Michel Eilshemius*, New York, Harry N. Abrams, Inc., 1978, pp. 50–52, pl. 3;. *The Romanticism of Eilshemius*, New York, Bernard Danenberg Galleries, 1973, pl. 35; *Masterpieces of Eilshemius*, New York, The Artists' Gallery, 1959, pl. 12.

21. *New York at Night* or *City Street in Moonlight*, ca. 1908

Signed lower right: Elshemus

Oil on masonite

20 x 14 inches

Robert K. Fitzgerel Collection

PROVENANCE

Artists' Unlimited Gallery, New York.

EXHIBITION

Rockland, Maine, Farnsworth Art Museum, 1985.

22. *New York Rooftops*, 1908

Signed and dated lower right: Elshemus 1908

Oil on masonite

30½ x 25½ inches

The Phillips Collection, Washington, D.C.

PROVENANCE

Valentine Gallery, New York; Kalamazoo Institute of Art, MI.

EXHIBITIONS

Paris, Galeries Durand-Ruel, *Oeuvres de Louis M. Eilshemius*, June 13–30, 1932, no. 37; New York, Valentine Gallery, October 1933; San Francisco, California, San Francisco Museum of Art, 1936; New London, Connecticut, Lyman Allyn Museum, November, 1943; New York, Valentine Gallery, *John Kane & Eilshemius*, November 12–December 1, 1945, no. 17; New York, Bernard Danenberg Galleries, *The Romanticism of Eilshemius*, April 1973, no. 29.

LITERATURE

The Romanticism of Eilshemius, New York, Bernard Danenberg Galleries, 1973, pl. 29; Paul J. Karlstrom, *Louis Michel Eilshemius*, New York, Harry N. Abrams, Inc., 1978, pg. 63, pl. 46.

23. *Trapping Bait*, 1908

Signed and dated lower right: Elshemus 1908

Oil on board

40 x 28 inches

Samuel L. Rosenfeld, New York City

PROVENANCE

Kleemann Galleries, New York; Florence Lewison Gallery, New York.

EXHIBITIONS

New York, Kleemann Galleries, 1939; New York, Kleemann Galleries, 1943, no. 2; New York, Florence Lewison Gallery, 1964, no. 24.

LITERATURE

Art News, October 14, 1939, p. 7; Paul J. Karlstrom, *Louis Michel Eilshemius*, New York, Harry N. Abrams, Inc., 1978, pl. 151; *Louis Michel Eilshemius*, New York, Florence Lewison Gallery, 1964 (cover illus.)

24. *Ellis Island from Battery (Dock with Figures)*, 1909*
Signed lower right: Elshemus
Inscribed on back in pencil: Ellis Island from Battery (1909)
Oil on board
21 x 14¾ inches

Courtesy of Berry-Hill Galleries, New York

PROVENANCE
Rev. Edward J. Reardon, New London, Connecticut.

EXHIBITIONS
New London, Connecticut, Lyman Allyn Museum, November 1943;
New York, The Artists' Gallery, *Masterpieces of Eilshemius*, April
1959, no. 10.

LITERATURE
Art News, April 1959, p. 27; *Magazine of Art*, February 1944, p. 50;
Masterpieces of Eilshemius, New York, The Artists' Gallery, 1959, pl. 10.

*Previously this work has been dated ca. 1907

25. *Kingsbridge*, 1909
Singed and dated lower left: Eilshemius 1909
Oil on board
20¼ x 30⁵⁄₁₆ inches

The Phillips Collection, Washington, D.C.

PROVENANCE
Valentine Gallery, New York.

EXHIBITIONS
San Francisco, California Palace of the Legion of Honor, *Exhibition of
American Paintings*, June 7–July 7, 1935, no. 317; Washington, D.C.,
The White House, April, 1954; Washington, D.C., The Phillips Col-
lection, *Renoir to Rothko: The Eye of Duncan Phillips*, September 25,
1999–January 23, 2000.

LITERATURE
The Phillips Collection Catalogue, 1952, p. 37; William Schack, *And
He Sat Among the Ashes*, New York, American Artists' Group, 1939,
p. 224; *Magazine of Art*, December 1939, p. 697 (illus.); Paul J. Karl-
strom, *Louis Michel Eilshemius*, New York, Harry N. Abrams, Inc.,
1978, pl. 169.

26. *Spanish Street Scene, Malaga*, 1909
Signed and dated lower right: Elshemius 1909
Oil on masonite
28¼ x 22¼ inches

Robert K. Fitzgerel Collection

PROVENANCE
Christie's, New York; Artists' Unlimited Gallery, New York; Florence
Lewison Gallery, New York.

EXHIBITION
Rockland, Maine, Farnsworth Art Museum, 1985.

27. *New York Street at Dusk*, ca. 1909
Signed lower right: Elshemus
Oil on paperboard
22⅛ x 28⅛ inches

Hirshhorn Museum and Sculpture Garden, Smithsonian Institution.
Gift of the Joseph H. Hirshhorn Foundation, 1966

PROVENANCE
Joseph H. Hirshhorn; Joseph H. Hirshhorn Foundation.

EXHIBITIONS
New Rochelle, New York, Iona College, *Creative Arts Festival for the Benefit of
Channel 13*, April 1–4, 1964; Washington, D.C., Hirshhorn Museum and
Sculpture Garden, Smithsonian Institution, *Louis M. Eilshemius: Selections from
the Hirshhorn Museum and Sculpture Garden*, November 9, 1978–January 1,
1979, no. 38 (toured US 1979–80); Washington, D.C., Hirshhorn Museum
and Sculpture Garden, Smithsonian Institution, *Bridging the Century: Images of
Bridges from the Hirshhorn Museum and Sculpture Garden Collection*, March
11–May 1987, no. 14.

LITERATURE
Paul J. Karlstrom, *Louis Michel Eilshemius*, New York, Harry N.
Abrams, Inc., 1978, pl. 163 (listed as *Twilight Street Scene, New York*);
Paul J. Karlstrom, *Louis M. Eilshemius: Selections from the Hirshhorn
Museum and Sculpture Garden*, Washington, D.C., Smithsonian Institu-
tion Press, 1978, p. 63 (illus.); Paul Richard, "Beckoning Bridges: An
Array of Images at the Hirshhorn," *Washington Post*, March 15, 1987,
F5.

28. *Yuma, Arizona*, 1909
Signed and dated lower left: Elshemius 1909
Oil on masonite
22 x 28⁵⁄₁₆ inches

Robert K. Fitzgerel Collection

PROVENANCE
Valentine Gallery, New York; Artists' Unlimited Gallery, New York.

29. *New York Houses*, 1910
Oil on paper
16½ x 8 inches

Roy R. Neuberger Collection

PROVENANCE
Valentine Dudensing, New York.

LITERATURE
Daniel Robbins, *An American Collection*, Providence, Rhode Island,
Museum of Art, Rhode Island School of Design, 1968, p. 149.

30. *In The Studio*, ca. 1911
Signed lower left: Elshemus
Oil on cardboard
22⅛ x 13¾ inches

The Museum of Modern Art, New York. Gift of Abby Aldrich
Rockefeller, 67.35

PROVENANCE
Valentine Gallery, New York; Mrs. John D. Rockefeller, Jr., New York.

EXHIBITIONS
New York, The Artists' Gallery, *Masterpieces of Eilshemius*, April
1959, no. 18.

LITERATURE
William Schack, *And He Sat Among the Ashes*, New York, American
Artists' Group, 1939, p. 200; *Art in America*, Summer 1959, p. 81;
Paul J. Karlstrom, *Louis Michel Eilshemius*, New York, Harry N.
Abrams, Inc., 1978, p. 92, pl. 182; *Masterpieces of Eilshemius*, New
York, The Artists' Gallery, 1959, pl. 18.

31. *Autumn Evening, Park Avenue, New York*, 1915
Signed and dated lower right: Eilshemius
Oil on board
26¼ x 36 inches

Roy R. Neuberger Collection

PROVENANCE
Valentine Dudensing, New York.

EXHIBITIONS
New York, Valentine Gallery, February 1937, no. 15; New York, M.
Knoedler & Company, Inc., *American Art, 1910–1960, Selections from
the Collection of Mr. and Mrs. Roy Neuberger* (benefit of the Fiftieth
Anniversary Fund, The American Federation of Arts), June 8–September
9, 1960, no. 16; Chicago, Illinois, Art Gallery, McCormick Place,
The Roy R. Neuberger Collection, January 5–March 1, 1961; Dallas
Museum of Fine Arts, *The Roy Neuberger Collection*, March 19–April 16,
1961, no. 10; Columbus, Ohio, Columbus Gallery of Fine Arts, *The Neu-
berger Collection*, January 9–February 23, 1964, no. 10; New York, The
Gallery of Modern Art, *About New York, Night and Day, 1915–1965*
(The Women's City Club of New York Fiftieth Anniversary Exhibition),
October 19–November 15, 1965; New York, Bernard Danenberg Gal-
leries, *The Romanticism of Eilshemius*, April 1973, no. 30.

LITERATURE
Daniel Robbins, *An American Collection*, Providence, Rhode Island,
Museum of Art, Rhode Island School of Design, 1968, p. 171 (illus.
p. 134); *Art in America*, Summer 1959, p. 82 (illus.); *The New York
Times*, Febuary 7, 1937, p. 9; *The Romanticism of Eilshemius*, New
York, Bernard Danenberg Galleries, 1973, pl. 30; Paul J. Karlstrom,
Louis Michel Eilshemius, New York, Harry N. Abrams, Inc., 1978,
pl. 202.

32. *Interior with Standing Nude*, ca. 1915
Signed lower right: Eilshemius
Oil on masonite
19 x 25⅞ inches

Robert K. Fitzgerel Collection

PROVENANCE
Chapellier Galleries, New York; The Fox Gallery, New York.

EXHIBITION
Rockland, Maine, Farnsworth Art Museum, 1985.

LITERATURE
William Schack, *And He Sat Among the Ashes*, New York, American
Artists' Group, 1939, p. 220.

33. *Malaga Beach*, ca. 1915
Signed lower left: Eilshemius
Oil on masonite
24⅛ x 39¾ inches

Collection of the New Jersey State Museum. Gift of Mr. and Mrs.
Lloyd B. Wescott, FA1971.58

PROVENANCE
Valentine Gallery, New York; Mr. and Mrs. Lloyd B. Wescott.

EXHIBITIONS
New York, Museum of Modern Art, *Art in Progress*, May 24–October
15, 1944; Newark, New Jersey, Newark Museum, 1946; New York,
The Artists' Gallery, *Masterpieces of Eilshemius*, April 1959, no. 25;
Washington, D.C., Phillips Gallery, *Masterpieces of Eilshemius*, May
10–June 1, 1959.

LITERATURE
Paul J. Karlstrom, *Louis Michel Eilshemius*, New York, Harry N.
Abrams, Inc., 1978, p. 77, pl. 196; William Schack, *And He Sat
Among the Ashes*, New York, American Artists Group, 1939, p. 219;
Masterpieces of Eilshemius, New York, The Artists' Gallery, 1959, pl.
25; *Time Magazine*, April 20th, 1959, p. 81.

34. *Self-Portrait*, 1915
Signed lower left: Eilshemius
Dated lower right: 1915
Oil on board
26½ x 18½ inches

Collection Gertrude Stein

PROVENANCE
Bertrand Russell.

35. *Central Park*, 1916
Signed lower left: Eilshemius
Oil on masonite
20 x 30 inches

Shirley and Jack Mandel

PROVENANCE
Valentine Gallery, New York; Adelaide Milton de Groot.

LITERATURE
William Schack, *And He Sat Among the Ashes*, New York, American Artists' Group, 1939, p. 237.

36. *Flower Girl*, 1916
Signed lower right: Eilshemius
Dated lower left: 1916
Oil on cardboard
30 x 22 inches

Roy R. Neuberger Collection

PROVENANCE
Valentine Dudensing, New York.

EXHIBITIONS
New York, Sidney Janis Gallery, *The High Kitsch of Eilshemius*, March 11–April 4, 1970, no. 29.

LITERATURE
Paul J. Karlstrom, *Louis Michel Eilshemius*, New York, Harry N. Abrams, Inc., 1978, pl. 211; Daniel Robbins, *An American Collection*, Providence, Rhode Island Museum of Art, Rhode Island School of Design, 1968, p. 173, illus. p. 206; *The High Kitsch of Eilshemius*, New York, Sidney Janis Gallery, 1970.

37. *Man on Horseback Near Los Angeles*, 1916
Signed and dated lower right: 1916 Eilshemius
Oil on board
30 x 40 inches

Roy R. Neuberger Collection

PROVENANCE
Valentine Gallery, New York.

EXHIBITIONS
New York, Graham Gallery, January 4–28, 1961, no. 9; American Federation of Arts traveling exhibition, *Paintings by Eilshemius from the Collection of Mr. and Mrs. Roy R. Neuberger*, October 1961–October 1962, no. 21; Columbus, Ohio, Columbus Gallery of Fine Arts, *The Neuberger Collection*, January 9–February 23, 1964, no. 12; New York, Bernard Danenberg Galleries, *The Romanticism of Eilshemius*, April 1973, no. 17.

LITERATURE
Daniel Robbins, *An American Collection*, Providence, Rhode Island, Museum of Art, Rhode Island School of Design, 1968, p. 174 (illus. p. 145); *The Romanticism of Eilshemius*, New York, Bernard Danenberg Galleries, 1973.

38. *Tragedy of the Sea (Found Drowned)*, 1916
Signed and dated lower right: 1916 Eilshemius
Oil on board
40½ x 61¼ inches

The Metropolitan Museum of Art, New York. Bequest of Miss Adelaide Milton de Groot (1876-1967), 1967. 67.187.160

PROVENANCE
Valentine Gallery, New York; Adelaide Milton de Groot.

EXHIBITIONS
Hartford, Connecticut, Wadsworth Atheneum, *The Adelaide Milton de Groot Loan Collection*, January 10–February 12, 1950 (listed as "Tragedy"); New York, The Artists' Gallery, *Masterpieces of Eilshemius*, April, 1959, no. 31; American Federation of Arts traveling exhibition, *The Figure in 20th Century American Art: Selections from The Metropolitan Museum of Art*, February 9, 1985–March 30, 1986; St. Paul, Minnesota, Minnesota Museum of Art, April 20–June 8, 1986.

LITERATURE
Paul J. Karlstrom, *Louis Michel Eilshemius*, New York, Harry N. Abrams, Inc., 1978, p. 75, pl. 56; William Schack, *And He Sat Among the Ashes*, New York, American Artists' Group, 1939, p. 239; Lloyd Goodrich, *New Art In America*, Greenwich, CT, New York Graphic Society, 1957, p. 36 illus.; *Masterpieces of Eilshemius*, New York, The Artists' Gallery, 1959, pl. 31; Doreen Bolger Burke, *American Paintings in the Metropolitan Museum of Art. Vol. III. A Catalog of Works by Artists Born Between 1846 and 1864*, New York, The Metropolitan Museum of Art, 1980, p. 463.

39. *Two Figures*, 1916
Signed and dated lower right: 1916 Eilshemius
Oil on board
39½ x 60½ inches

Collection Gertrude Stein

PROVENANCE
Unknown.

40. *Despondent*, 1917
Signed lower right: Eilshemius
Oil on cardboard
30½ x 40½ inches

Collection Neuberger Museum of Art, Purchase College, State University of New York. Gift of Roy R. Neuberger

PROVENANCE
Valentine Gallery, New York.

EXHIBITIONS
Columbus, Ohio, Columbus Gallery of Fine Arts, *The Neuberger Collection*, January 9–February 23, 1964, no. 15.

LITERATURE
Paul J. Karlstrom, *Louis Michel Eilshemius*, New York, Harry N. Abrams, Inc., 1978, pl. 216; Daniel Robbins, *An American Collection*, Providence, Rhode Island, Museum of Art, Rhode Island School of Design, 1968, p. 179.

41. *The Haunted House*, ca. 1917

Signed lower right: Eilshemius
Oil on masonite
30 x 39¾ inches

The Metropolitan Museum of Art, New York. George A. Hearn Fund, 1937. 37.41

PROVENANCE
Valentine Gallery, New York.

EXHIBITIONS
San Francisco, California, California Palace of the Legion of Honor, *Exhibition of American Paintings*, June 7–July 7, 1935, no. 316; New York, The Metropolitan Museum of Art, *20th Century Painters; A Special Exhibition of Oils, Watercolors, and Drawings Selected from the Collections of American Art in The Metropolitan Museum of Art*, 1950; New York, The Artists' Gallery, *Masterpieces of Eilshemius*, April 1959, no. 35; New York, The Metropolitan Museum of Art, *Three Centuries of American Painting*, 1965.

LITERATURE
William Schack, *And He Sat Among the Ashes*, New York, American Artists' Group, 1939, p. 258; Henry Geldzahler, *American Painting in the Twentieth Century*, New York, The Metropolitan Museum of Art, 1965, p. 119–120, no. 213; *Masterpieces of Eilshemius*, New York, The Artists' Gallery, 1959, pl. 35; Doreen Bolger Burke, *American Paintings in the Metropolitan Museum of Art Vol. III. A Catalogue of Works by Artists Born Between 1846 and 1864*, New York, The Metropolitan Museum of Art, 1980, p. 463; Paul J. Karlstrom, *Louis Michel Eilshemius*, New York, Harry N. Abrams, Inc., 1978, p. 39, 59, pl. 221.

42. *North Africa*, 1917

Signed lower right: Eilshemius
Oil on masonite
23¼ x 35¾ inches

Robert K. Fitzgerel Collection

PROVENANCE
Artists' Unlimited Gallery, New York; Bernard Danenberg Galleries, New York; Chappelier Galleries, New York; Bogart Gallery, New York.

EXHIBITIONS
New York, Bernard Danenberg Galleries, *The Romanticism of Eilshemius*, April 1973, no 19.

LITERATURE
The Romanticism of Eilshemius, New York, Bernard Danenberg Galleries, 1973, pl. 19.

43. *The Prodigy*, 1917

Signed and dated center top: Eilshemius 1917
Oil on composition board
39⅜ x 36 inches

Private Collection

PROVENANCE
H.P. Roché, Paris; Jon Streep, New York; Heir of Jon Streep, New York.

LITERATURE
William Schack, *And He Sat Among the Ashes*, New York, American Artists' Group, 1939, p. 240; Pontus Holten, ed., *Marcel Duchamp Work and Life: Ephemerides On and About Marcel Duchamp and Rose Selavy, 1887–1968*, Cambridge, Massachusetts, MIT Press, 1993, illustrated in relation to entry 13-9-20.

44. *Zeppelin in Flames Over New Jersey*, 1937

Signed lower right: L.M. Eilshemius
Oil on cardboard
18½ x 15½ inches

Collection of the New Jersey State Museum, Trenton. Museum Purchase, FA1969.159

PROVENANCE
Berry-Hill Galleries, New York.

EXHIBITION
New York, Berry-Hill Galleries, *Paintings by Eilshemius*, November 1–30, 1968, no. 28.

LITERATURE
The Art Quarterly, Winter 1969, p. 443; Paul J. Karlstrom, *Louis Michel Eilshemius*, New York, Harry N. Abrams, Inc., 1978, p. 78, 107, pl. 227.

45. *Early Morning*, n. d.

Signed lower right: Elshemius
Oil on board
30½ x 41 inches

Salander-O'Reilly Galleries, New York

PROVENANCE
Cooperative Gallery, Newark, New Jersey.

EXHIBITIONS
New Jersey, Kean College, *Reconstructed*, February 7–March 19, 1981.

MILTON AVERY

Portrait of Louis M. Eilshemius, 1942
Signed lower left: Milton Avery
Oil on canvas
35⅞ x 28 inches

Smithsonian American Art Museum. Gift of Louis and
Annette Kaufman, #1976.40

PROVENANCE
Louis and Annette Kaufman.

LITERATURE
Paul J. Karlstrom, *Louis Michel Eilshemius*, New York, Harry N.
Abrams, Inc., 1978, pl. 2.

Information compiled from Paul J. Karlstrom, "Louis Michel
Eilshemius, 1864–1941: A Monograph and Catalogue of the Paintings
(Volumes I and II)," Ph.D. diss., University of California, Los Angeles,
1973.

SELECTED BIBLIOGRAPHY

Publications By Eilshemius

Music

Lillian. Earnest W. Strack, New York, 1902, 5 pp.

Love's Faith. Earnest W. Strack, New York, 1902, 5 pp.

Oenone (And Eigth Other Tone-Pictures). The Dreamers Press, New York, 1911, 35 pp.

Six Musical Moods (For the Piano). Eastman Lewis, New York, 1897, 24 pp.

Violet. Earnest W. Strack, New York, 1902, 5 pp.

Zapparella (A Musical Love). Luckhard & Belder, New York, 1900, 7 pp.

Prose, Novels and Short Stories

The Devil's Diary. Abbey Press, New York, 1901, 271 pp. Prose.

Evening. The Dreamers Press, New York, n.d. 7 pp.

Fragments and Flashes of Thought; Lost Love and Poems and Ballads. The Dreamers Press, New York, 1907, 508 pp.

Nannie (A Song of the Heart). The Gorham Press, Boston, 1907, 38 pp.

Sweetbrier. Abbey Press, New York, 1901, 239 pp. Novel.

A Triple Flirtation. Abbey Press, New York, 1900. Collection of short stories, including "Charity."

Periodicals

The Art Reformer, 1, nos. 1-4 (May, June, October, November 1909); 2, nos. 1-4 (September-December 1911), nos. 5, 6 (January, February 1912). The Dreamers Press and Eastman Lewis, New York.

Three Arts' Friend (A Monthly), 1, nos. 2, 5 (November, February). New York, 1925, 1926. Additional numbers were probably published.

Verse

About Girls: Unpoetical and Poetical Maidens. The Dreamers Press, New York, 1907, 187 pp.

Companionship. The Dreamers Press, New York, 1909, 16 pp.

Creation's End (A Four Page Epic and Two Other Poems). The Dreamers Press, New York, 1925, 15 pp.

A Few Culled Flowerets Scattered in a Tome. T. Symonds, Paris, 1887, 44 pp. Published under the pen name "Micah Enos."

Inspirations (Lyrics as I Hear Them in My Soul and Not After Patters of Man). The Dreamers Press, New York, 1907, 64 pp.

"Lady"Vere (and Other Narratives). Eastman Lewis, New York, 1897, 126 pp.

Mammon. Eastman Lewis, New York, 1897, 126 pp.

Moods of a Soul. Peter Paul Book Company, Buffalo, 1895.

My Brother Victor (A Convalescent's Fancy). The Dreamers Press, New York, 1912, 28 pp.

Mystery and Truth (A Sonnet-Sequence). The Dreamers Press, New York, 1907, 34 pp.

The Poet and Elegaic Poems. The Dreamers Press, New York, 1907, 155 pp.

Poetical Works. The Abbey Press, New York, 1901, 500 pp. Contains *The Course of Love.*

Sixty Sonnets (Thoughts and Emotions). The Dreamers Press, New York, 1904, 36 pp.

Songs of Southern Scenes. The Dreamers Press, New York, 1904, 154 pp. Identified as "2nd ed."

Songs of Spring and Blossoms of Unrequited Love. Peter Paul Book Company, Buffalo, 1895, 157 pp.

Thoughts at Night-Time. The Dreamers Press, New York, 1909, 16 pp.

Publications about Eilshemius

Books

Karlstrom, Paul J. *Louis Michel Eilshemius.* Harry N. Abrams, Inc., New York, 1978.

_____. "Louis Michel Eilshemius, 1864–1941: A Monograph and Catalogue of the Paintings (Volumes I and II)." Ph.D. dissertation, University of California, Los Angeles, 1973.

Schack, William. *And He Sat Among the Ashes.* American Artists Group, Inc., New York, 1939.

Exhibition Catalogues

Duchamp, Marcel and Katherine S. Dreier. *Collection of the SociÈtÈ Anonyme: Museum of Modern Art, 1920.* Yale University Art Gallery, New Haven, 1950.

Dudensing, Valentine. *Twenty Selected Paintings by Eilshemius, An Authentic American Artist.* Valentine Gallery, New York, 1933.

Janis, Sidney. *The High-Kitsch of Eilshemius.* Sidney Janis Gallery, New York, 1970.

Karlstrom, Paul J. *Louis M. Eilshemius: Selections from the Hirshhorn Museum and Sculpture Garden.* Smithsonian Institution, Washington, D.C., 1978.

_____. *The Romanticism of Eilshemius.* Bernard Danenberg Galleries, New York, 1973.

Exhibition Catalogue. *Masterpieces of Eilshemius*. The Artists' Gallery, New York, 1959.

Robbins, Daniel. *An American Collection (The Roy R. Neuberger Collection)*. Rhode Island School of Design, Providence, 1968.

Venturi, Lionello. *Paintings by Louis M. Eilshemius*, foreword . Durand-Ruel Galleries, New York, 1942.

Articles

Karlstrom, Paul J. "Eilshemius: Grand Eccentric of American Art," *Smithsonian Magazine*, Washington, D.C., November 1978.

Lane, James. "Triple Eilshemius Festival," *Art News*, 38, New York (14 October 1939), p. 7.

Loy, Mina. "Pas de Commentaires! Louis M. Eilshemius," *The Blind Man*, no. 2 (May 1917).

McBride, Henry. "The Discovery of Louis Eilshemius," *The Arts*, 10 (December 1926), pp. 316-20.

_____. "The SociÈtÈ Anonyme Discovers Eilshemius," *Evening Sun* (New York), 19 April 1924.

McCausland, Elizabeth. "Art of Louis M. Eilshemius at the Berkshire Museum," *Springfield Republican*, Springfield, Massachusetts, 9 January 1935.

_____. "An Independent American. Louis Eilshemius, the American Painter-Poet," *Springfield Sunday Union and Republican*, 23 August 1936.

"Mahatma Louis Eilshemius," *Newsweek*, 14, New York, (23 October 1939), p. 40.

Phillips, Duncan. "The Duality of Eilshemius," *Magazine of Art*, 32 (December 1939), pp. 694-97, 724-27.

Ratcliff, C. "New York Letter: Louis Eilshemius," *Art International*, 14 (May 1970),
p. 86.

Reardon, Edward J. "The Eilshemius Pendulum," *Magazine of Art*, 37 (February 1944), pp. 48-50.

Riley, Maude. "Eilshemius at 45," *Art Digest*, 18 (15 December 1943),
p. 5.

Schack, William. "Eilshemius," *Parnassus*, 7 (October 1935), pp. 6-8.

_____. "Eilshemius Rediscovered, 1939 and 1959," *Art in America*, 47, no. 2 (Summer 1959), pp. 78-83.

Watson, Forbes. "Louis Eilshemius," *New York World*, 14 November 1926, p. 13-E.

Finis.